DRAWING FROM MEMORY.

THE CAVE METHOD

FOR

LEARNING TO DRAW FROM MEMORY.

BY

MADAME MARIE ELISABETH CAVÉ.

TRANSLATED FROM THE FOURTH PARIS EDITION, REVISED CORRECTED, AND ENLARGED BY THE AUTHOR.

To See, to Understand, to Remember, is to Know.—RUBENS.

Copyright © 2013 Read Books Ltd.
This book is copyright and may not be
reproduced or copied in any way without
the express permission of the publisher in writing

British Library Cataloguing-in-Publication Data
A catalogue record for this book is available from the
British Library

Drawing and Illustration

Drawing is a form of visual art that can make use of any number of drawing instruments, including graphite pencils, pen and ink, inked brushes, wax colour pencils, crayons, charcoal, chalk, pastels and various kinds of erasers, markers, styluses, metals (such as silverpoint) and even electronic drawing. As a medium, it has been one of the most popular and fundamental means of public expression throughout human history – as one of the simplest and most efficient means of communicating visual ideas.

Drawing itself long predates other forms of human communication, with evidence for its existence preceding that of the written word – demonstrated in cave paintings of around 40,000 years ago. These drawings, known as pictograms, depicted objects and abstract concepts including animals, human hands and generalised patterns. Over time, these sketches and paintings were stylised and simplified, leading to the development of the written language as we know it today. This form of drawing can truly be considered art in its purest sense – the basic forms on which all others build.

Whilst the term 'to draw' derives from the Old English *dragan* (meaning 'to drag, draw or protract'), the word 'illustrate' derives from the Latin word *illustratio*, meaning 'enlighten' or 'irradiate'. This process of 'enlightenment' is central to drawing and illustration as we know it today. Medieval codices' illustrations were often called 'illuminations', designed to highlight and further explain

important aspects of biblical texts. This was the most general form of illustration; hand-created, individual and unique. This changed in the fifteenth century however, when books began to be illustrated with woodcuts – most notably in Germany, by Albrecht Dürer.

The first creative impulses of a painter or sculptor are commonly expressed in drawings, and architects and photographers are commonly trained to draw, if for no other reason than to train their perceptual skills and develop their creative potential. Initially, artists used and re-used wooden tablets for the production of their drawings, however following the widespread availability of paper in the fourteenth century, the use of drawing in the arts increased. During the Renaissance (a period of massive flourishing of human intellectual endeavours and creativity), drawings exhibiting realistic and representational qualities emerged. Notable draftsmen included Leonardo da Vinci, Michelangelo and Raphael. They were inspired by the concurrent developments in geometry and philosophy, exhibiting a true synthesis of these branches – a combination somewhat lost in the modern day.

Figure drawing became a recognised subsection of artistic drawing in this period, despite its long history stretching back to prehistoric descriptions. An anecdote by the Roman author and philosopher Pliny, describes how Zeuxis (a painter who flourished during the 5th century BCE) reviewed the young women of Agrigentum naked before selecting five whose features he would combine in order to paint an ideal image. The use of nude models in the medieval artist's workshop is further implied in the writings

of Cennino Cennini (an Italian painter), and a manuscript of Villard de Honnecourt confirms that sketching from life was an established practice by the thirteenth century. The Carracci, who opened their *Accademia degli Incamminati* (one of the first art academies in Italy) in Bologna in the 1580s, set the pattern for later art schools by making life drawing the central discipline. The course of training began with the copying of engravings, then proceeded to drawing from plaster casts, after which the students were trained in drawing from the live model.

The main processes for reproduction of drawings and illustrations in the sixteenth and seventeenth centuries were engraving and etching, and by the end of the eighteenth century, lithography (a method of printing originally based on the immiscibility of oil and water) allowed even better illustrations to be reproduced. In the later seventeenth and eighteenth centuries, the previous combination of the arts and sciences in drawing gave way to a more romantic and even classical style, epitomised by draftsmen such as Poussin, Rembrandt, Rubens, Tiepolo and Antoine Watteau. Mastery in drawing was considered a prerequisite to painting, and students in Jacques-Louis David's Studio (a famed eighteenth century French painter of the neo-classical style), were required to draw for six hours a day, from a model who remained in the same pose for an entire week!

During this period, an increasingly large gap started to emerge between 'fine artists' on the one hand, and 'draftsmen' / 'illustrators' on the other. This difference became further complicated with the 'Golden Age of Illustration'; a period customarily defined as lasting from the

latter quarter of the nineteenth century until just after the First World War. In this period of no more than fifty years the popularity, abundance and most importantly the unprecedented upsurge in quality of illustrated works marked an astounding change in the way that publishers, artists and the general public came to view artistic drawing. Arthur Rackham, Walter Crane, John Tenniel and William Blake are some of its most famous names. Until the latter part of the nineteenth century, the work of illustrators was largely proffered anonymously, and in England it was only after Thomas Bewick's pioneering technical advances in wood engraving that it became common to acknowledge the artistic and technical expertise of illustrators. Such draftsmen also frequently used their drawings in preparation for paintings, further obfuscating the distinction between drawing/painting, high/low art.

The artists involved in the Arts and Crafts Movement (with a strong emphasis on stylised drawing, and a powerful influence on the 'Golden Age of Illustration') also attempted to counter the ever intruding Industrial Revolution, by bringing the values of beautiful and inventive craftsmanship back into the sphere of everyday life. This helped to counter the main challenge which emerged around this time – photography. The invention of the first widely available form of photography (with flexible photographic film role marketed in 1885) led to a shift in the use of drawing in the arts. This new technology took over from drawing as a superior method of accurately representing the visual world, and many artists abandoned their painstaking drawing practices. As a result of these developments however, modernism in the arts emerged – encouraging 'imaginative

originality' in drawing and abstract formulations. Drawing was once again at the forefront of the arts.

There are many different categories of drawing, including figure drawing, cartooning, doodling and shading. There are also many drawing methods, such as line drawing, stippling, shading, hatching, crosshatching, creating textures and tracing – and the artist must be aware of complex problems such as form, proportion and perspective (portrayed in either linear methods, or depth through tone and texture). Today, there are also many computer-aided drawing tools, which are utilised in design, architecture, engineering, as well as the fine arts. It is often exploratory, with considerable emphasis on observation, problem-solving and composition, and as such, remains an unceasingly useful tool in the artists repertoire.

The processes of drawing is a fascinating artistic practice, enabling a beautiful array of effects and creative expression. As is evident from this short introduction, it also has an incredibly old history, moving from decorations on cave walls to the most advanced, realistic and imaginative drawings possible in the present day. It is hoped that the current reader enjoys this book on the subject.

EDITOR'S NOTE.

THE REVUE DES DEUX MONDES has published an article by M. Eugène Delacroix, the illustrious painter, upon DRAWING WITHOUT A MASTER, by Madame Marie Elisabeth Cavé. We cannot do better than republish it here in order to call public attention to her work.

*Drawing without a Master, by Madame Elisabeth Cavé.**

This is the only method of drawing which really teaches anything. In publishing as an essay the remarkable treatise in which she unfolds with surpassing interest the result of her observations upon the teaching of drawing and the ingenious methods she applies, Madame Cavé, with whose charming pictures every one is familiar, not only proves that she has carefully studied the principles of the art she practises so well, but she also renders invaluable service to all who have marked out for themselves a career of art. She clearly shows the pernicious effects of the ordinary methods, and how uncertain are their results. She has indisputably the first claim to attention; she speaks of that with which she is well acquainted; and her piquant manner of presenting truth renders it only the more clear. I do not purpose in noticing her work to follow in the steps of those who, without thoroughly understanding the art of painting—without even having practised its elements, write upon it, and give officious advice to artists.

The pupil who goes with his portfolio under his arm, to study at the Academy rarely reads writings of this sort; and the finished painter who has taken his bent and chosen his path, has neither the leisure nor the power to recreate or modify himself after their systems; moreover, these works generally treat less of practice than of theory. The real evil is the incompetent teacher, the unskilful usher of that sanctuary which he himself will never penetrate; the poor painter who pretends to teach and explain what he has never been able to put in

* From Revue des Deux Mondes.

practice, the method of making a good picture. The treatise of Madame Cavé is a timely interposition between these sorry professors and their victims. We must charge to the account of their fatal doctrines, or rather to the absence of all doctrine in their mode of instruction, the few attractions we have all found at the beginning of the career. Who does not remember the pages of noses, ears and eyes which afflicted our childhood? Those eyes, methodically divided into three perfectly equal parts—the central one occupied by the eyeball, which was represented by a circle; that inevitable oval the point of departure for drawing the head, which is neither oval nor round, as every one knows; in short, all those parts of the human body, copied endlessly and always separately, and requiring in the end a new Prometheus to construct therefrom a perfect man. Such are the notions beginners receive, and which are through life a source of error and confusion.

Can we wonder at the general aversion toward the study of drawing? Madame Cavé, however, as she says in her preface, would have this study, like reading and writing, form one of the elements of education; by suppressing all false methods, and rendering instruction, not only systematic but easy, she would cause a most happy revolution; she would guide unerringly, the first steps of the artist in the long career before him; and open to persons of leisure, to mere amateurs, a source of enjoyment equally lively and varied. Painting, which imparts such deep pleasure to the connoisseur capable of appreciating the delicacies of this beautiful art, confers still higher good upon those who themselves wield the crayon or the brush, whatever may be the grade of their talent. Without aspiring to composition, one may find real delight in imitating all that nature presents. Copying fine pictures is also a real amusement, which makes study a pleasure; the memory of beautiful works is thus preserved by means of labor unaccompanied by that

fatigue and anxiety which the inventor experiences. The trouble and the toil are truly his.

The poet Gray used to say that he desired nothing more for his portion in Paradise, than the privilege of reading at his leisure, stretched upon a sofa, his favorite romances; such is the enjoyment of copying. It has been the pastime of the greatest masters, and is an achievement as easy for talent which aims higher, as for the amateur who is not ambitious of overcoming the utmost difficulties.

Among the ancients, the knowledge of drawing was as familiar as that of letters; and how can we suppose it was not like the latter, an element of their education? The wonders of invention and science which shine not only in the relics of their sculpture, but in their utensils, their furniture, in every article they used, attest that their acquaintance with drawing was as extended as that with writing. There was more poetry with them, in the handle of a saucepan, or in the simplest pitcher, than in the ornaments of our palaces.

What critics those Greeks must have been! What tribunal for an artist can be equal to a whole nation of connoisseurs? It has been repeated to satiety, that the habit of seeing the nude figure familiarized them with the beautiful, and made them quick to discern faults in painting and sculpture. It is, however, a great error to suppose that nudity was as common as many imagine, among the ancients; our familiarity with statuary has fostered this prejudice. The paintings which have been handed down to us from the ancients exhibit them in ordinary life, dressed in every variety of style, wearing hats, shoes, and even gloves. The Roman soldiers wore pantaloons; the Scotch in this respect come nearer simple nature. Rich people, who affected oriental manners and costumes were weighed down, as we see the rajahs of India, with ornamental attire, to say nothing of the necklaces, the gilded clasps and varied coiffures

Even if we suppose that the public games and gymnastics in which they habitually indulged made them more familiar than we are in modern times, with the body in motion and entirely nude, is that a sufficient reason for attributing to them a thorough acquaintance with drawing?

With us the face is always uncovered—is the sight of such a multitude of countenances productive of many connoisseurs in protraiture? Nature spreads her landscapes lavishly before our eyes, yet great landscape painters are none the more common.

"Learn to draw," says the author of '*Le Dessin sans Maître*' "*and you will have your idea at the end of your pencil as the writer has his at the tip of his pen*," learn to draw and you will carry with you in returning from travel, souvenirs far more interesting than would be the journal in which you should endeavor to record every day, your emotions in each locality, before each object. That simple pencil sketch beneath your eyes, recalls with the scene there portrayed, all the associations connected with it—what you were doing before or after—what your friends around you were saying—and a thousand delicious impressions of sun, air, and the landscape itself which the pencil cannot translate. More than that, it enables the friend who could not follow you in your journeyings, to enter, as it were, into your emotions, and where is the description, either written or oral, which has ever conveyed a complete idea of the object described? I appeal to all who, like myself, have lingered in delight over the romances of Walter Scott, and I select him because he excels in the art of word painting; is there a single one of those pictures so minutely detailed, of which it is possible to have a perfect conception? It would be amusing to take one of his descriptions and propose to a dozen skilful painters to reproduce upon canvas the objects described by this enchanting writer. I have not the least doubt there would be entire disagreement in the results.

I have heard one of the most illustrious writers of our time say that, during a very interesting tour in Germany, he made repeated efforts to transfer upon paper, with letters and words,—those usually docile instruments of his thought—the aspect, the color, and even the poetry of the scenery, with its mountains and rivers, through which he passed, and he fully confessed he was quickly out of conceit with so dry a task; better fitted, in my mind, to weaken reminiscences than to strengthen them.

But how shall we learn to draw? The course of study requisite for the lowest degree in College lasts ten years; ten years, passed under the ferule and upon the bench, scarcely give to ordinary students the general knowledge of the ancient writers. Where shall time be found for the long apprenticeship in which the great masters spent their entire lives, and that in the absence of all method? For there really is none in the study of drawing. The student finds neither in the books nor even in the instructions of a master, anything analogous to rudiments and syntax. The best master, and this will be the one who shall lay aside all those useless practices which mere routine makes habitual—such a master can do no more than place a model before his pupil telling him to copy it as well as he can.

A knowledge of nature resulting from long experience, gives to the finished painter a certain skill in the process employed to reproduce what is seen; but, instinct still remains to him a surer guide than reason.

This is why the great masters never stopped to give precepts upon the art they practised so well; the inspiration of their favorite duty was, undoubtedly, the best of all counsellors to them almost without exception; they have disdained leaving the least written instruction or traditions of practical method. Albert Dürer has treated only of proportions—mathematical measurements taken from an arbitrary base—but that is not drawing.

Leonardo da Vinci, on the contrary, in his " Treatise

on Painting," pleads routine almost exclusively; a new argument in support of our assertions. This universal genius—this great geometrician has made his book only a collection of recipes.

There has been no lack of systematic minds, and here I do not refer to common drawing-teachers, who have rebelled against the impotence of science.

Some have drawn by circles, others by squares; they have improvised most extraordinary methods; Madame Cavé's idea from its very simplicity has never occurred to one of them. "Learning to draw" she tells us, "is but training the eye correctly,"—it matters little what sort of a machine the professor may be if one's chief study is the cultivation of the eye; reason, and even sentiment should come afterward.

Drawing is not the reproduction of an object as it is —that is the sculptor's task—but as it appears—and this is the work of the draughtsman and the painter; the latter completes by means of the gradation of tints what the other began with the proper disposition of lines; perspective, in a word, must be *not in the mind, but in the eye of the pupil.* "You teach me nothing but truths," I say to the master, with your exact proportions and your perspective by *a plus b*, whereas in art all is illusion; what is long must appear short, what is curved should seem straight, and, reciprocally. What is painting in its literal signification?

The imitation of projections upon a plain surface. Before poetry can be expressed in painting, objects must be brought out from the back ground; and this achievement was the work of centuries. It began with the cold barren outline, and reached perfection in the marvellous creations of Rubens and Titian, in which the salient points as well as the simple outline, expressed each in proper degree, have concealed art by force of art. There is the *ne plus ultra*, there is the miracle, and this is the fruit of illusion.

Give, as Madame Cavé says, a piece of clay to a peasant, telling him to make a ball out of it; the result will be, with more or less success, a ball. Hand to that novice in sculpture, a sheet of paper and pencils, asking him to solve the same problem with instruments of another kind, drawing the object upon the paper and rounding it off by means of *black* and white, you will find it difficult merely to make him understand what you require; it will be years before he can model even passably by the aid of drawing.

Madame Cavé's sole aim is to cultivate the eye correctly. Thanks to her method, which is simplicity itself, proportion, contour and grace, will come of themselves and appear on the paper or the canvas. By means of a tracing of the object to be represented upon transparent gauze, her pupil cannot help acquiring a knowledge of foreshortenings, that stumbling-block in all kinds of drawing. She accustoms the mind to all the absurdities and impossibilities it presents. By requiring the repetition from memory of the outline, taken as it were *in the act*, she gradually familiarizes the beginner with difficulties; this calls in science to the aid of growing experience, and at the same time opens to the pupil the career of composition, which would be forever closed without the assistance of drawing from memory.

Impelled by a similar idea many artists have resorted to photography as a means of correcting the errors of the eye, and I agree with them, notwithstanding the opinion of those who criticize the method of teaching by tracing through glass or gauze, that the study of the photograph if thoroughly pursued, may of itself take the place of instruction. Much experience is necessary, however, to derive any benefit therefrom. The photograph is superior to the tracing; it is the mirror of the object—certain details, usually overlooked in designs from nature, there assume characteristic importance, and thus introduce the artist into close acquaintance with

construction; the lights and shades are there reproduced in their true character, that is, with their exact degree of firmness, or softness; a very nice distinction—without which there can be no projection. But we must not lose sight of the fact that the photograph is only a translator whose office it is to initiate us beforehand in the mysteries of nature, for notwithstanding its wonderful truth in some respects, it is still only a reflection of the real, only a copy—false to a certain extent, from the very necessity of being exact. The monstrosities it presents are truly shocking, even though they may literally be those of nature herself; but these imperfections which the machine reproduces with fidelity, do not offend our eyes when we look at the model without this medium; the eye unconsciously corrects the disagreeable exactness of rigorous perspective; it performs the work of an intelligent artist; in painting it is mind speaking to mind, and not science to science. This remark of Madame Cavé is the old quarrel of the letter and the spirit; it is a criticism upon those artists, who, instead of taking the photograph as a counsellor, as a kind of dictionary, make it the picture itself. They imagine they are following nature much more closely when, by dint of extreme care they have preserved in their painting the results at first obtained mechanically. They are bewildered by the hopeless perfection of certain effects seen upon the surface of metal. The more they attempt any resemblance, the more they discover their inability. Their work is, therefore, only a necessarily cold copy of a copy imperfect in other respects. The artist, in a word, becomes a machine, drawn by another machine.

Photography naturally leads me to speak of what Madame Cavé says of portraiture. There is not a more delicate art. A person who moves, who speaks, does not exhibit imperfections like a mute, motionless picture. We always examine a portrait too closely; we notice it more in one day than the original in ten years. A por-

trait initiates the beholder in details he had never before observed. For example, we often hear a person say when looking at a portrait, "It is a good likeness but the nose is too short." Then turning to the original, he adds, "I never observed you had so short a nose, but you have a very short nose!" These remarks clearly show the task of the portrait painter; and this task notwithstanding the received opinion which classes portraiture as an inferior art, requires superior and entirely distinct faculties.

We understand the skill of the portrait painter to consist in softening the imperfections of his model, at the same time preserving the resemblance, and Madame Cavé's method of solving this difficulty is at once simple and ingenious. Certain outlines may be modified, embellished, so to speak, without destroying the peculiar features. Study the character of a head, try to discover what strikes us at first view. There are persons who possess this faculty naturally, and they take a likeness before they learn to draw. I call that a good likeness which pleases our friends, leaving no room for our enemies to say "It flatters!" And this is no easy achievement. How many good portrait painters are there, that is, painters who combine real talent with the art of producing a good likeness? Very few. Often a simple sketch is a better likeness than a portrait, because the latter is too minutely detailed. Do you know the color of all your friends' eyes? Certainly not. It results from the fact that we notice our immediate acquaintances very slightly. Hence this question arises: Is it necessary that the portrait painter should show us more than we have been accustomed to observe? Examine the portraits painted from photographs,—not one in a hundred is endurable. Why is it so? Because it is not regularity of feature which impresses and charms us, but the *tout ensemble*—the expression of the face—for every one has a physiognomy which strikes us at first sight and

which a machine can never render. It is the spirit which must be understood and rendered in the person or object drawn. And this spirit has a thousand different faces; there are as many expressions as sentiments. It is a wonderful work of God, the forming of so many different faces with a nose, a mouth and two eyes. For who of us has not a hundred faces? Will my portrait of this morning be that of this evening or to morrow? Nothing repeats itself: each instant brings a new expression.

I shall not extend my remarks to all portions of this charming treatise, whose chief merit is, perhaps, its brevity.

In these narrow limits, the author touches upon all points which can interest a pupil as well as an experienced painter: the art of choosing the point of view, of disposing the lights and shades, in short, all the instruction which can be given upon composition; the whole is presented in a few words; she does not forget, in that department of art which is the summary of all the others, to enjoin care in the selection of subjects. As she has the good taste and I may add, the extreme modesty to address herself only to women, this caution is the more important; I might remark that not a few men would derive benefit from her suggestions; the mania for attempting subjects or styles out of the range of their capacity, has ruined many clever artists. The prejudice which measures talent by the dimensions of the work, should exist only among these who are no judges of painting. How artists who appreciate and admire as they deserve, the master-pieces of the Flemish and Dutch find something to envy when they themselves produce remarkable works of similar dimensions! *There are no degrees*, says Madame Cavè, in the value of the objects sculptured or painted, *the degree exists only in the talent of the artist who executes.* The crowning injunction which is the starting point of all instruction, is then the following: Consult, first of all, the genius of your pupil

"At the present day," she says again, "artists are made in spite of Minerva: we say to the young man, 'you will be a painter, a sculptor,' as we should say, 'you will be potter or a carpenter,' without studying in the least his aptitude. We forget that genius alone can say to youth, 'you will be an artist.' Evidently, it was otherwise in ancient times."

"See that streamlet," she says elswhere, "which follows lovingly, the channel nature has prepared for it, bearing freshness and plenty in its undulating course, enriching itself with little brooks which join it on the way, and finally reaching the sea. a majestic river; that is the emblem of talent and genius; nothing is an effort; it follows its natural course. It is not thus with inferior natures, with them all is borrowed labor; like those canals, excavated by innumerable hands through the mountains, and which become dry, if the neighboring stream does not supply them: artificial tides without grace, without life."

One may see by these casual quotations, that my task is an easy one: these striking images so simply expressed which one meets here and there and in due moderation, are the accompaniment of her precepts and give an idea of the manner in which the subject is treated. It is difficult to give a complete analysis of a theme so instructive and so clearly presented; one can only repeat in another form the simple truths which the author places before her readers. In speaking to the young girls who are her pupils, and in so familiar a style, Madame Cavé presents to artists of all classes, most interesting ideas to meditate upon and treasure up.

I wish, further, to notice her lesson upon the advantage to be derived from studying the great masters. Her reflections upon their different merits seem to me a brief solution of the grave question which has filled volumes and still appears unanswered. It is no less a theme than "*the beautiful*,"—that beauty which some

have made to consist in a straight line, others in the serpentine, and which the author of this treatise finds simply wherever there is anything to admire. Study the differences existing between these great talents (she has just enumerated the great masters of the different schools). Some are of the first rank, others of the second: but there is beauty in all; in all, material for instruction. What I specially enjoin is, not to be exclusive. Some painters are ruined by adopting only a certain style and condemning all others; all, however, should be studied impartially; thus one preserves his originality, since he follows in the steps of no one master. The pupil of all, is the pupil of no one; and from the united lessons received, he creates his own wealth. While one master is absorbed in studying the minutest details of nature, another aims only at picturesque effects, grand contours. The latter have represented, in historical painting, memorable scenes from ancient life; the former have painted naturally and without effort, the most common place view just as it was presented to them. Some have sought inspiration in the ideal, others in the real. Paul Veronese threw air and light every where with profusion; Rembrandt enveloped himself in a profound, mysterious light and shade. The former is delicate, the latter vigorous. All are different but all natural. If the women of Rubens are unlike those of Titian and Raphaël, it is because the Dutch do not resemble the Italians. Even more, in the same country, Titian, Raphaël, Paul Veronese, disagree regarding form, for each painter has his style, his predilection; each has painted his own ideal of woman, and he has not erred; he has painted the beautiful as he saw it.

I will leave the reader under the impression of these clear and sensible thoughts. I have added no comment. They will serve as a conclusion, and may lead to a better understanding as to the respective qualities of the

great masters, and above all as to the famous "*beautiful*" which has caused such sleeplessness to so many great philosophers, while other rare men solved it without effort.

<p align="center">EUGENE DELACROIX.</p>

REVUE DES DEUX MONDES, *Sept.* 15, 1850.

P.S.—Do not confound le " *Dessin sans Maître* " with le " Dessin appris seul," which is not by the same author

DRAWING WITHOUT A MASTER.

WITH this method as simple as it is ingenious, parents, and teachers, without knowing how to draw themselves, may teach children the art—now as indispensable as reading and writing.

The report upon this work made to the Minister of the Interior by M. Felix Coitereau, Inspector-General of Fine Arts, which we publish here, and in consequence of which that minister has subscribed for a great number of copies, is the best eulogium we could offer upon this method which will soon be the only one in use in all the schools.

We cannot be too urgent in recommending persons who wish to follow this method, to address for drawing models which may be relied on as those selected and approved by Madame Cavé, M. Philipon, Rue Bergère, 20; also the office of "L'Ane Savant" 69 Boulevard Saint Martin, which publishes the third part of the "*Dessin*" and Coloring without a Master.

(See close of the book for the nomenclature of articles necessary to this method.)

Report of the Inspector-General of Fine Arts to the Minister of the Interior, upon Madame Cavé's Method of Drawing.

March 28, 1851.

IN accordance with your instructions I have examined the results of Madame Cavé's method for teaching the

art of drawing, which she has explained in her book entitled "Drawing without a Master."

Tracing a drawing or some object in nature through a thin gauze, reproducing the image traced and ascertaining by means of the proof if the reproduction is exact—this is the starting-point of this method which possesses the advantage of disciplining at once the hand and the eye of the pupil, even obliging her to discover and correct her own errors without the aid of a teacher. In Madame Cavé's studio the proof is the instructor; that is to say, is the truth.

This first exercise is followed by drawing from memory; the pupil is required to reproduce without the aid of the model, the drawing which she has previously traced and copied. These first lessons are addressed to children of from eight to twelve years, and I have established the following results:

1st. A remarkable correctness in the *ensemble* and *contour* of a figure or any other object:

2d. A reproduction from memory scarcely distinguishable from the copy:

3d. Acquaintance with the masters; I have readily recognized Raphaël, Holbein, and others, in the drawings from memory of Madame Cavé's pupils, and I thus conclude they have for themselves become familiar to a certain degree with the great masters:

4th. Finally, the idea of perspective; that is, that without having learned any of the rules of the science, pupils, in tracing from nature execute correctly the greatest difficulty in the art of perspective foreshortening.

Thus, by exercising the memory of children, giving accuracy of vision and firmness of hand at the age when their organs, still tender, are docile, Madame Cavé renders them better qualified for the industrial professions, makes them skilful instruments in all the trades which pertain to art.

With the old methods one could not learn to draw

before the age of twelve, a period which terminates the education of the working-classes, because the judgment is not developed. With the ingenious teaching of Madame Cavé, the child, learning almost unconsciously to observe and compare, forms his own judgment, at the same time acquiring that skill which is indispensable in every species of manual labor.

Here, then, we have genuine improvement in the education of the children of the people.

After designating the means of rendering the elements of drawing as common as the art of writing, Madame Cavé goes still further: young girls who have passed the age of twelve make rapid progress; in looking over their numerous essays I have seen shading added to outlines; the eye of the pupil acquires such accuracy, she disposes her lights and shades so boldly, that her first design astonishes one; it possesses qualities which ordinarily are the results only of long experience. It is the same with designs from nature. With this method, falsity is impossible, for the truth is ever before the pupil's eye; if she wanders from it she is forced to return. Drawings from memory, then, assume greater importance. Many have been shown me representing entire pictures with the lights and shades. It is certain that the pupil who is successful in reproducing a picture from memory, with all its difficulties, understands it. The requisite effort of mind endows her to a certain degree with the science of the picture.

To balance a composition, to distribute the lights, are two great secrets in the art of painting in which Madame Cavé's method initiates one in the simplest manner. Her pupils have not yet attained so far, but the works of the professor clearly prove the value of her precepts.

Accept, Sir, the tribute of my respect.

FELIX COITEREAU,
Historical Painter, Inspector-General of Fine Arts.

PREFACE.

ALL men are not poets or writers because they have passed ten years of their life in a college. Yet all, whatever may be their calling, derive benefit from their studies. All know how to hold a pen and to express their thoughts sufficiently. It is, as it were, the first step in the art of writing which the most ordinary minds attain.

I am often asked why the art of representing objects with the pencil, as thoughts are reproduced by the pen, is not as common as the art of writing. It is certainly as necessary. We may safely assert there is no man of leisure who has not a thousand times regretted his ignorance of drawing, either when he has wished a house built, an article of furniture made, a garden laid out, or to preserve the remembrance of some locality, some noted edifice, or work of art. And where is the industrial profession which has no need of drawing? The joiner and the cabinet-maker, the carpenter and the builder, the florist, the embroiderer, the milliner, the mantua-

maker, the manufacturer of shawls and cloths, the potter, the crockery-maker and a thousand others,—are only imperfectly acquainted with their occupation, if they are strangers to this art. It imparts taste, and enables them to select beautiful designs, impressing their works with that seal of elegance which renders them sought after.

If we revert to ancient times, not only do we find monuments and works of art which strike us with admiration, but the vessels and commonest utensils are in the most exquisite style.

Why are the artists and even the workmen of antiquity, so superior to our own? Why do we at the present day servilely copy the ancients, distorting their works in our vain attempts to equal them?

Because artists are now made in spite of Minerva. We say to the young man, "You will be a painter, a sculptor," as we should say, "You will be a potter, or a carpenter," without studying his proclivities in the least. We forget that genius alone can say to youth, "You will be an artist." It was apparently otherwise in ancient times.

As to the artisans, whose works have emerged to our great astonishment, from the soil of Pompeii, we do not know that they could read, or write, but they certainly knew how to draw, and much better than the majority of our artists.

Evidently, the art of drawing was not in Rome as with us, an accomplishment.

An accomplishment, a superfluous something, superficially acquired and quickly forgotten, is the name now bestowed upon the art of drawing, which, to the artisan, is at least as useful, as necessary, as the art of writing. Is it astonishing, that with this prejudice, our industrial professions retrograde instead of progressing?

We say, then, to artists, in order that they may instruct the people—to the people, that they may listen to the teaching of the artist: "Whoever would wield to advantage any industrial profession, should learn to draw."

We say to the rich, "your children may be deprived of the wealth you now enjoy—let them learn to draw, and in misfortune, they will bless you for having given them a talent, an invaluable resource, which no one can take from them."

A method has been recently adopted by which one learns in two or three years to draw from memory, anything presented to the mind.

With this method, while one learns to copy the objects which are before the eye, they are so graven upon the memory as to be reproduced at will; eye memory is the most common and the simplest. After six weeks of study, our pupils themselves are surprised at their familiarity with what they draw.

Drawing from memory is having one's thought, the expression of that thought, at the point of his pencil as the writer has his at the tip of his pen. All the great masters drew from memory; hence their originality.

Consulting, copying, kills invention and genius; composing, putting the thoughts rapidly upon paper by the aid of memory, that is the true process of invention.

DRAWING WITHOUT A MASTER.

FIRST LETTER.

DEDICATION.

You are correct, my dear Julia. If you do not compel me to put my method in writing it will remain only a project of my brain, and will never see the light. You have presented a motive for overcoming my indolence: " I wish my daughters to have a profession, if reverses should overtake them. Their fate is in your hands. Write to me and I will interpret your lessons to them. Hereafter, other mothers will thank you with me, when your letters shall be given to the press."

The press! that, dear friend, is an ugly word—it fills me with fear. Speak to a woman of the printer, and you take away what wit she has. You understand that I do not write for the press. If you betray me I shall have done my duty as a friend, and shall be pardoned, for a woman is not compelled to be an author. Her first duty is to fulfil courageously and with dignity the sacred mission with which she is entrusted by the

Creator. What an admirable sphere is assigned to woman! How unworthy the name are those who desire to be men! Yet is not this desire the natural growth of our social organism? Men having monopolized every thing, women in seeking to be something say, " Let us be men!" They are not aware how much they lose. To reinstate their minds in the truth, it is only necessary to make them realize what they are, and what they may become. You are no longer dependent, if you do not wish to be. A host of professions belong to you; you may make these vases, these clocks, jewels, mirrors, in short all the works of art which excel in ingenuity and elegance. You may monopolize the designs for robes, cashmeres, tapestry, you will attain a delicacy in little things which the hand of man can never equal, and you will execute works worthy of Penelope. We know what man can do, but we can form no idea as to what woman will accomplish. We must remember that it is scarcely fifty years since her education first attracted attention, while that of man has been cared for, more than four thousand years.

I wished to dedicate my method to you, but my son counsels me to inscribe it to Mary your elder daughter. Mary is the name for all young girls, yours will represent them all for me. I intend to play the part of a mother, not of a professor.

Without any pretension, and by conversation, I will begin then to teach *drawing from memory.*

Remember these words and repeat them to your daughters. *Drawing from memory, is to have one's thought, the expression of that thought, at the point* of his pencil, as the writer has his at the tip of his pen. All the artistic careers are open to those who acquire this talent. Instinct, genius, will impel them in different directions; but every where and always, they will find useful occupation.

My object will be attained, if some day, pleased, or at least diverted by my instructions, they bestow a thought upon me and thee, my dear Julia, whose maternal solicitude has impelled me to take up the pen.

<div align="right">M. E. C.</div>

SECOND LETTER.

LESSON.—THE TRUE TEACHER.—DRAWING FROM MEMORY.

You are not in so wild a country, my dear Julia, as to be unable to procure a veil of white gauze and four pieces of wood shaped like flat rules.

You will adjust these rules in the form of a square slightly elongated, and stretch the gauze upon it. Thus you will obtain a kind of frame, the glass of which will

be gauze; then purchase common drawing-paper and charcoal.

Would it not be better, however, for me to send you the whole from Paris, since I am obliged to send you models? I shall purchase them of Susse, who has already sold me the gauzes called Rouillet. They supply the place of the frame used by the ancients.

The box will reach you two days after this letter, and on opening it you will first notice the sheet containing a list of necessary utensils; do not begin anything until the articles there mentioned are all collected.

The pupil should be in a good position, properly seated with her feet firmly on the floor: she should have the back of the chair before her to support the board upon which she is to draw: a pasteboard never affords a perfectly plane surface (1).

The pupil will place the gauze on the chair before her, so that she can take it up and lay it down with ease.

When she has sharpened two or three sticks of charcoal very fine, she will fasten her sheet of paper upon the board with four paper tacks—carpet tacks or wafers will answer—so that it will be perpendicular.

This properly done, you will hand your pupil the first series of models, heads of men and animals, feet, hands, trees, and she will select the one which appears most simple.

The model chosen, and placed on the board before the pupil, you will say to her:

Put your gauze over this model and trace with the charcoal (2). Trace until the tracery is perfect, and pay careful attention to what you are doing, for presently you are to copy the model.

The tracing finished, you call it the proof; this serves as the professor. Then you replace it on the chair. The model is then placed perpendicularly before the pupil.

We come now to the second operation : drawing from the model. The pupil copies her model.

While thus occupied she may, whenever she wishes, apply the proof to the outlines already executed, either to correct them or to verify their accuracy; this proof is her faithful instructor, not a prating professor filling the ear of his pupil with unintelligible phrases, but a silent teacher responding to the earnest eyes which consult him only by presenting the truth. Such instructors are always heard and understood.

With the proof applied to the drawing, how can the pupil help seeing her faults? and she will realize and correct them so much the better for having recognized them herself. She will thus in time produce a drawing similar to the proof and therefore to the model. To efface the marks, an old glove will answer. I requested that the charcoal be sharpened very fine, because the outline should

be very light yet perfectly distinct. It may be erased when the drawing is finished with a bit of muslin, and restored delicately upon the faint outlines.

The first drawing of a pupil after this method, possesses this remarkable merit; it is correct in the lines and the expression of character, a difficult attainment, yet this is the essence of drawing.

While your pupil is thus employed, do not fail to repeat: Pay attention to what you are doing, for when you have finished your drawing, I shall take away the model and you must reproduce it from memory.

"That is impossible!" the pupil will respond. But you will be firm, you will require some expression of her idea and you will obtain it.

She will make a sketch smaller or larger than the original, it is immaterial; generally, pupils in drawing from memory make it smaller.

You will understand that when there are several models upon the same sheet, the pupil executes but one of them. You will require her to draw it from memory before attempting another.

You will gain confidence in my method from this fact, that, by simply following your pupil attentively, you will be able to give her advice when she attempts drawing from memory. And imperfect as this design may be, it yet will astonish you.

DRAWING FROM MEMORY. 31

The memory of the eye is not the same with all persons. Some have more, some less. Like the other faculties it is strengthened by use. Often those who naturally possess the least, aquire it to a superior degree. But we will resume our lessons, for the first series is yet to be executed.

You will number the first two drawings thus : " No. 1. drawing with proof. No. 2. drawing from memory ;" and preserve them as a starting-point. Thus with the others to the last. I pledge myself you will not wait for the last to express your surprise at the progress of your pupil, either in what she can accomplish with the model or from memory.

When a pupil can execute every day, a drawing after the model and one from memory, her progress is much more rapid. But it is absolutely necessary that the two drawings be made the same day, otherwise, it will be difficult to produce the second from memory. Two or three hours work is enough for one day.

One thing more is requisite, that your daughters in the evening of the same day, make a fresh appeal to their memory, by repeating in a small sketch-book with a lead pencil, the model of the day (3).

At the second lesson, the same process. The model chosen is to be traced in order to obtain the proof; then copied, correcting it by the proof; then reproduced from

memory. See that the last model is executed from memory before a new one is undertaken.

If a pupil finds great difficulty in retaining the memory of the model, you will permit her to trace it the second or third time, as often as she wishes, until she has in some degree impressed it upon her mind. I have thus obtained happy results from the poorest of all my pupils. My efforts with her have suggested this method. By repeated exercises I have succeeded in giving her eye, hand, and memory. I have completed my task by demonstrating the advantages of drawing from memory.

You remember how we used to say when at boarding-school, " It is impossible ! I can never put all that in my head !" and yet, we did learn when we willed to do so. Because we were compelled, we were taught to learn. Learn how to learn, that is the whole secret.

<div align="right">M. E. C.</div>

N. B. You will not accept a drawing until it has been submitted to the proof and found entirely correct. The proof may be of transparent paper. See sixth letter at the close of the Method.

THIRD LETTER.

OBSERVATIONS—THE VOCATION.

Your letter, my dear Julia, is very welcome. I have awaited it impatiently. "Has she fully comprehended me?" "Have I made my instructions sufficiently clear?" Such were my questionings when your cheering words were received. All goes on well, then; you are inclined to think your daughters possess extraordinary talent. My pupils make the same impression upon me and upon the artists who see their drawings. In short, you are pleased, and should not I be also? The task which used to be fatiguing is becoming a delightful occupation.

You regret that you are not fifteen again, in order to be thus instructed? Ungrateful one! Is it not far sweeter for you to witness the return of that youth in your daughters, to watch the unfolding of their beauty and intellect? For they are now at an age when all their faculties are developed. At fourteen or fifteen the judgment begins to form. They no longer think through others but for themselves; they see with their own eyes, they compare objects and actions, they discern the foibles of the great, become familiar with beauty and deformity, youth and age, they observe the shadows which

reveal light upon the face, the effects of the sun in field and wood, they notice that objects diminish in receding, and that a tree in the distance is smaller than a person very near.

What phenomena are revealed, from the rough mountain which, seen in the horizon, appears of a pure blue or a cloud-like gray, to the straight walk whose extremities are equidistant, yet seem to contract like a tunnel?

In walking with your daughters, teach them to observe when you have a wide prospect before you, how its extent may be reduced by perspective. To this end, plant a cane before this horizon, and seat yourselves fifteen steps distant: you will see an entire landscape develop in half or even a quarter of the cane. For this reason in drawing the perspective of a landscape it is necessary to be seated very low ; note this in passing.

Before the age of fourteen or fifteen, all these observations escape one. For how can the eyes retain what they have never perceived? Their memory is a work of comparison and judgment. One cannot draw objects like a monkey without reflection, just as one repeats words parrot-fashion without understanding them.

Learn to see well, correctly; can anything be more important?

One of my pupils said to me one day, after two or three months of study. "What a change! I look at

nothing with indifference! Everything interests me. The objects that pass before my eyes, have a form, color, details that I never perceived until now. I seem to have entered a new world.

This pupil knew that when my lessons are not exactly followed I cease to give them. The first results had surprised her. Hence her care to notice well in order that she might reproduce correctly. Hence my control over her imagination. Acknowledge, dear friend, that it is a pleasure thus to develop the faculties of youth. You have reason to thank me for opening to you this source of delight; I call it the happiness of God, since one really creates. Every day brings new attractions; each model, each lesson is different; you enter a domain, richer and more varied than nature, since it is nature herself, studied and understood.

Drawing from memory as executed by your pupils, in no way resembles, what is called drawing by *knack;* you must be impressed with its *naïveté.* This truth of expression sometimes fails in drawings made after the model; though the former may be wavering in execution, it is correct in conception and action, while drawing by *knack,* however skilful in execution, is false in design. This accuracy, this truth to nature, results from the care with which the pupil corrects herself by the proof. This guides her in the right or recalls her when she has

erred. If for instance, you say to her, this nose is too long, she will either shorten it but little or none at all, because she has drawn it according to her own observation. But when she herself, applies the proof to her work, she is convinced of her error and corrects it. Thus she arrives certainly at truth. The proof is a mirror, it is the object itself.

You see, my dear Julia, no greater flights of imagination are requisite to apply what I have written thus far; and it is the same with what I shall write hereafter. Everything is simple, easy beyond our realization, because truth is always sought at a distance when it is under the hand. People torture themselves very much in this world, to attain an end instead of simply trusting to one's own genius.

See that streamlet which follows lovingly the channel nature has prepared for it, bearing in its undulating course, freshness and plenty to its flowing banks, enriching itself with little brooks that join it on the way, and finally reaching the sea, a deep majestic river; that is the emblem of great talent and genius. Nothing is an effort to them, they follow their bent.

It is not so with inferior natures; with them all is borrowed, labored, like those canals excavated by many hands through the mountains, and which become dry if

the neighboring stream does not supply them, artificial tides without grace, without life.

When I said, my dear Julia, "Let your pupils select the design which appears most simple," I meant, "Let them follow their bent." Thus their genius will express itself. One chooses animals, another faces, another landscapes. So far from interfering with this taste, this preference, it should be cherished. It is the water from the fountain which takes its natural course.

But they should understand that there are no degrees in the value of the objects sculptured or painted. The degrees exist only in the talent of the artists who execute. If the great paintings of Raphaël were sold by measure at the value of the Flemish, no one would be rich enough to purchase them; not even the whole of California would be sufficient to pay for the colossal statues if they were sold by the foot at the same price as the jewels of Benvenuto Cellini. Young girls especially need this injunction, for they are too often dazzled by the idea of great paintings—historical paintings, as they are now called. The ambition to equal men, to compete with them proves their ruin.

Woman the rival of man—what a burlesque! It is as absurd as a bird would be fastened to a plough, or an ox which should attempt to fly. What strength would

the bird have with all its grace, what grace the ox with all its strength?

Women competitors with men! But why not?

When you look at an oak do you think of exclaiming, "This oak is ugly, I like the rose better?"

Wherefore this emulation in great things when nature herself delights in the perfection of the least? Is not the mechanism of the smallest insect which walks and flies, more extraordinary than that of the goose which can do no more? Is the diamond colossal? Is not the plumage of the bird more wonderful, more finished than the donkey's mane? Every one admires a beautiful tree, but how many are there whose eye and mind are sufficiently disciplined to analyze a flower and to comprehend the infinite delicacy of its structure?

This, my dear Julia, is reserved for our pupils. When they shall draw flowers from memory, they will catch the idea, dissecting them as models for ornaments, for it is with flowers, fruits, animals, children, and women, that we make those coquettish compositions which belong to us, and which in the future will be executed only by women. To each an appropriate task.

<div style="text-align:right">M. E. C.</div>

FOURTH LETTER.

LESSON.—PAGES OF SHADING AND CAPITALS.

It is useless, my dear Julia, to send you models of capital letters and pages of shading.

Your daughters will make capitals with the crayon, just as they do with the pen.

And as to shading, a lithograph will give them all the values of tone, which they can imitate one after another.

Have the shading very carefully executed, whether with the lead pencil, with red chalk or red crayon.

The pupils should cover entire sheets with their efforts until they become skilful in handling the crayon, until the grain of the shading is perfectly regular, and appears only a uniform tint, without a single crayon stroke predominating, or even showing in what direction they have been given. These elements prepare the way for solid drawings, such as masses of shade and light.

The crayon is more difficult to handle than the charcoal; drawings retouched by the crayon lose much of their merit when the pupil does not understand using the crayon with suppleness and without heaviness. It is

not by bearing on that black is produced, but by passing over and over the same place and always very lightly In this way mellowness is obtained and dryness avoided.

The pupil should hold her crayon inclined, not perpendicularly, as in writing. She should not press it between the fingers. This observation is important.

Now we come to capitals; your pupils will execute all the letters of the alphabet, and in different proportions. This is a theme for excellent and varied exercises; the route of the pupils is all laid out; they will not weary of it if they have any taste for drawing, and for yourself you will not neglect to repeat, "Do not bear on!" "Pass many times over the same place!" "You hold your crayon too tightly!" "It is not sufficiently inclined." And as nothing is insignificant, recommend to your pupils to use their bits of crayon in a holder; a small piece of crayon in the fingers gives only a hard, ill-formed outline.

I have said enough upon shading and capitals. Let us return to our studies. The crayon is now laid aside and the charcoal plays its part. Here let me ask you to refer to my second letter, to recall what you may have forgotten upon this rule. The pupil should not take a new model until the last shall have been conscientiously executed from memory.

Even if contrary to my expectations, your pupils do

not take pleasure in executing pages of shading and capitals (it is generally the unpromising, thankless ones who find these exercises monotonous), I urge you to insist, even to severity.

All art has its difficulties, these are slight ones. Are the first lessons in dancing agreeable? Courage and perseverance!

<div style="text-align: right">M. E. C.</div>

P. S.—Pupils who are very desirous to learn, often execute the same drawing three times. Once corrected by the proof, once from memory, and again without the proof. The drawing from memory should always be made after the one corrected by the proof.

As M. Ingres, says, in approving this method, "Before allowing a pupil to draw from memory, she should previously have made a drawing mathematically correct; otherwise by repeating her faults, they are engraven in the mind."

FIFTH LETTER.

OBSERVATIONS — PREJUDICES — THE GREAT MASTERS — THE EDUCATION OF PAINTERS.

You remember our great professor of music, who was half blind and whose mind ———— but that did not hinder him from being a good musician.

He said to me one day: " You have no more talent than a horse; you play entirely from memory; you will never be a musician, never play at sight."

To play at sight, was at that time an ambition; this was the standard of musical talent. As if one were a poet because he reads verses well! But as much time was then spent in learning to read music, it was considered a talent. At the present time, when good methods have been discovered which teach one in six months to read upon all the clefs, ideas have changed upon this point and upon many others. This reading at sight is now only a facility, which does not in the least prove one to be a musician, and playing from memory, on the contrary indicates favorable musical talent. Simplification leads us more directly to an end. Take the child who learns to read without spelling; she retains more easily from seeing

than from spelling, that p-h-a make fa, and that f-e-m make fem. So music is now read by intervals. It is the simplest, most logical idea, yet is the last to be adopted. By it all the clefs are reduced to one.

There you see many prejudices destroyed. It will be the same with those encountered in the study of drawing.

There is no lack of painters who pretend that it is injurious to draw from memory; this is the old story of the fox; they condemn this faculty because they do not possess it, and give as a reason that it destroys simplicity; truth to nature. They mistake simplicity for ignorance.

My dear pupil, it is preëminently the drawing executed from memory, which will enable you better to execute the one you are to attempt after the model. Whoever can do much can do little. When you know how to construct a head and find yourself face to face with another head, you will seize at once upon the differences and harmony existing between the two. Harmony is a sure guide. The difference is quickly seen, well understood, and therefore easy to express. Is not the great difficulty in the art of drawing that of seeing well?

As soon as you see correctly you feel correctly, you execute correctly.

How many great painters who are very unskilful! How many poor ones who possess astonishing address. "Distrust your facility," Gros used to say; it is your worst enemy. In fact if the hand rules the head, you will fall into the common-place knack. You are the slave of a crayon-stroke skilfully given. On the contrary, if you follow your eye, your observation, you will secure correctness, you will find truth, you will be natural, and naturalness is simply truth.

This accuracy, this naturalness, is the result of much observation, of great memory. That, my dear Julia, is what I wish to give my pupils. It is everything. You will appreciate this assertion when we talk about drawing from nature.

But before giving your pupils lessons from nature, they should know how the great masters have interpreted her. When you walk out with your daughters, I advise you to see if there are not some articles worthy of purchase in the picture and curiosity stores. I have no doubt they would like to employ their savings in making portfolios. There is great pleasure in collecting the masterpieces of the great artists. Their names are not always affixed to their works. It will be best at first to purchase only those with signatures.

It is an excellent point of departure for the education of your daughters.

EDUCATION OF PAINTERS.

The following are the names of the principal masters you will seek for:

HISTORICAL PAINTERS.

Raphaël,	Poussin,
Titian,	Correggio,
Rubens,	Leonardo da Vinci,
Van Dyck,	Andre del Sarto,
Paul Veronese,	Murillo,
Rembrandt,	Jordaëns,
Le Sueur,	Gericault, etc.

GENRE PAINTERS.

Metzu,	Boucher,
Terburg,	Chardin,
Gerard Dow,	Moreau,
Miéris,	Téniers,
Vatteau,	Greuse,
Lancret,	Pierre de Hog, etc.

LANDSCAPE PAINTERS.

Ruisdaël,	Berghem,
Van Ostade,	Salvator Rosa,
Claude Lorraine,	Carel Dujardin, etc.
Paul Potter,	

When you have collected a portion of these masters, endeavor to have your daughters study the differences existing between these great geniuses. Some are of the first rank, others of the second; but there is beauty in

all; in all, material for instruction. What I especially enjoin is, not to be exclusive. Some painters are ruined by adopting only a certain style and condemning all others. All, however, should be studied impartially. Thus one preserves his originality, since he follows in the steps of no one master. The pupil of all is the pupil of no one; and from the united lessons received he creates his own wealth. How much to observe in this little museum, where you will direct the intellect of your daughters! While one master is absorbed in studying the minutest details, another aims only at picturesque effects, grand masses. The latter have represented in historical painting, memorable scenes from ancient life; the former have painted naturally, and without effort, the most commonplace scene, just as it was presented to them. Some have sought inspiration in the ideal, others in the real. Paul Véronèse, threw air and light everywhere with profusion. Rembrandt enveloped himself in deep mysterious light and shade. The former is gentle, the latter vigorous. All are different, and all are natural.

If the women of Rubens are unlike those of Titian and Raphaël, it is because the Dutch are not like the Italians. Even more, in the same country, Titian, Raphaël, Paul Véronèse, disagree regarding form; for each painter has his style, his predilection; each has painted

his ideal of woman, and he has not erred; he has painted beauty as it manifested itself to him.

Call the attention of your pupils, also, to the hands in the works of the old masters. They are all very beautiful, yet unlike. Each painter has his distinct hand. It is so in nature. Notice carefully the pretty hands of your acquaintance; some are those of Raphaël, others of Titian, others of Vatteau, etc., Nature has made them for all tastes, for all painters.

After observing a little, according to those observations, (pardon this play on words), your daughters will soon know how to appreciate a good engraving. Perhaps they will soon bring home an unsigned masterpiece, purchased for a trifle. How excited they are! See them compare the nameless engraving with the one signed! Are they from the same master? "No," "Yes." How disappointed they are if deceived! But how delighted, when a Raphaël or a Rubens is discovered.

And as acquaintance with engraving leads to acquaintance with painting, what interest and emotion attend a visit to the Museum.

The education of the painter is like that of the child; it begins in the cradle, since its first principle is seeing correctly, comparing surrounding objects; and this study is renewed and continued every day. Holding the pencil constantly, working incessantly like a machine,

will never create talent. He must live continually with his art, take interest in all that relates to it, concentrate all upon it, and apply it everywhere. There is nothing which does not teach something to the painter.

From the engravings collected in their portfolios your pupils may trace either heads, hands, or entire figures of men or animals, whatever pleases them most. For this they may use transparent paper. The tracings thus made should be carefully preserved, with the name of the master affixed, in an album; where they may be fastened with lip-glue. This will enable the pupil to classify the masters in her mind, and to remember the characteristics of each.

Hereafter these tracings will serve as guides, correctors, when she is sufficiently skilful to make pretty sketches from the engravings. (4.) .

I recommend substituting the transparent paper for the gauze, so that the minutest details may be traced and executed afterwards. Means all the more sure are indispensable the nearer we approach perfection. Thus, gradually, the pupil will execute drawings of such a character, that they will be attributed to the masters themselves.

I have no doubt your daughters will soon make this attainment, only on condition, however, that my instructions are followed with exactness.

If you could see all that experience has taught and is teaching me every day, I should count on your perseverance.

<div align="right">M. E. C.</div>

SIXTH LETTER.

LESSON.—THE CRAYON TAKES THE PLACE OF CHARCOAL.

You say, my dear Julia, that you are delighted with the progress of your daughters; the younger, Eliza, who used to know nothing, has overtaken the elder. That does not astonish me. Mary, who had already used the crayon, looked upon charcoal sketches as beneath her notice. That is an error, for charcoal is the painter's friend. Hereafter when she attempts composition, she will understand the words of one of our most distinguished artists. "Charcoal is master."

She must already appreciate it in drawing from memory. One cannot be too skilful in the delicate use of this species of pencil. We shall soon come to studies where it is much more difficult to employ it.

Drawing from memory becomes little by little to your daughters, as to my pupils, a decided recreation; and it is perfectly natural. When the pupil has conscien-

3

tiously finished her drawing, taking pains to correct it frequently by the proof, she has performed a fatiguing labor it must be admitted, but a very useful one; for it is just this persistent attention which imprints the model on her mind. And when intelligence is freed from such thraldom, what use she makes of her freedom! How rapidly mind and memory combine in creating with the pencil! One is astonished oneself, at what is retained, at what is accomplished.

Already you tell me you find the manner of sketching the model becomes bolder, clearer, and much more correct.

This progress is inevitable, and ought to be speedy. Every time a pupil has deviated from the truth, she has been forced to return. To those who enlarge, as well as to those who contract—the more common fault—the traced proof has always given the true proportions. It has put a compass in their eye; an old saying, but it expresses my idea.

When the pupil copies, she should let her pencil fall perpendicularly before the model, holding it very lightly; she will find her vertical line as also her other guide, by poising the pencil horizontally before the model.

Nevertheless she must redouble her attention. In order to make her traced proof, it is important that the paper be fastened perfectly straight upon the board, as

I have indicated; the drawing will have all necessary precision. If precision is used in the means, it will be manifest in the results.

The charcoal sketch being finished, the pupil will repass over the charcoal delicately with a very soft crayon, carefully regarding the form. Then with her glove, she will remove all the charcoal, and there will remain only a faint outline like a spider's web. Small drawings may be executed with the lead pencil, and large ones with a crayon. (5.)

This is the point at which your pupil enters upon the minutest details; therefore, greater care is requisite in the execution of the model.

Do not forget this observation, that in the shade, the outline is always vigorous, and in the light, always delicate. Point out to her what escapes her notice. You should allow her to do nothing mechanically. It is only lost time. One pencil stroke rationally given, its purport understood, is worth more and benefits more, than a hundred strokes given without reflection.

Here, my dear Madame, you are to reap pleasure, if you have taught with firmness; otherwise a great disappointment awaits you. You remember my request that the pages of shading and capital letters should be executed with care and in great number. If I have been obeyed, the first pencil stroke of your daughter Eliza

before the model will be good; if not, it will spoil the charcoal. In that case she must return to the shading exercise.

But if Mary's drawing is good, and I presume it will be since she has already crayoned, she may, without delay execute it from memory; beginning with the charcoal and finishing with the crayon.

The memory is exercised still more pleasingly in this second study, because the pupil having drawn the model twice in succession, once with the charcoal, and once with the crayon, has it more thoroughly engraven upon the mind. Then the result being more satisfactory in the drawing after the model, it is more so in the drawing from memory. Still another step will be gained, if in the evening your daughters repeat the lesson of the day in their sketch-books.

Heavily shaded landscapes exercise the hand in using the crayon. The broad zones of sky always commence extremely light, and blend with the darker portions of it, by such subtle gradations that the labor is never suspected. There are no more useful studies than such lithographs; they render shading exercises interesting.

But I must stop here. I ought not to make my letters too long, since a single one furnishes material for thirty lessons. Your daughters undoubtedly know how to use the crayon, but they do not shade yet.

You tell me they have worked regularly three hours a day (6) excepting Sunday. That is an excellent method of regulating the lessons so as to make rapid progress. You may judge so yourself, since in seeing what they accomplish, no one would believe they have so little time to study. It is certain that at Madame C——'s soiree, where they designed charades, much surprise was created. This is a little gratification of which my pupils are very fond, and which they seek somewhat coquettishly. Drawing from memory, excites the emulation of every one : so my studio is like a society of freemasons; no pupil betrays her secret; self-respect will not allow her to reveal the means she employs for learning so rapidly.

Yet all have the greatest desire to see this method in print. Explain that if you can, signora professore.

<div style="text-align: right">M. E. C.</div>

SEVENTH LETTER.

OBSERVATIONS—WOMAN TRULY WOMAN—BEAUTY AND DEFORMITY.

You ask, my dear friend, if you shall permit your daughters to copy the lithographs of Gavarni; they take

great pleasure in doing so, you say. I must compliment their taste in selecting the works of this artist; it is a proof that they have already studied nature, and are charmed at seeing her thoroughly understood and expressed.

Gavarni will leave to posterity a very correct idea of the manners and the style of his contemporaries. That is a desirable attainment for woman, whose mind possesses such tact in observing the details of familiar life, and whose delicate raillery could so well bring them out in relief. Gavarni, however, will still be the master.

I remember his saying to me one day, that success in lithography is impossible without knowing how to draw from memory.

You have doubtless noticed that it is just his manner of shading which I teach. The work does not show itself, hence its charm. In masses of shading the less there is of detail, the fewer distractions.

The charcoal giving a dead tint, the effect of a charcoal-drawing is very pleasing.

For that reason, in imitation of the great professors, I teach water-colors by flat tints.

One thing I would recommend; and it is to improve every opportunity of becoming acquainted with our modern masters.

Their names recur so often in the journals that it

is scarcely necessary to give a list of them. I will mention only Rosa Bonheur, because she is a woman, and because she paints animals with wonderful skill.

As I look at the admirable works of this artist, I congratulate myself for having said, "We have no conception of what our sex can do." When woman shall learn how to possess talent without ignoring her womanhood, she will astonish man; and what is still better, she will charm him. What original and pleasing illustrations she can give; that of Berquin, for instance! Could any man have delineated it with such grace and expression?

But when a woman desires to paint large-sized pictures, and mounts the ladder, she is lost—lost as a painter—lost as a woman. As a painter, she will fail in force; as a woman in grace. Why descend from the pedestal upon which the Creator has placed us, giving us that happy feebleness which is irresistible! It is such an admirable combination—the strength of man with the delicacy of woman! And though I cannot tell how, without arms, powder, or ball, we move the world and place her mighty conquerors at our feet.

So instruct your daughters that they lose not the privileges of their sex, by indulging in those masculine exercises which can only injure their loveliness and deprive them of all their grace.

I cannot see what a woman gains, but I know how much she loses, in mounting a horse or swimming. We have been created with extremely delicate organs. Women are jewels; they need a casket. Thus we are loved by men; their greatest happiness is to promote ours; stronger than we, they love to make sacrifices for us, even as we love to make sacrifices for our children, more helpless than ourselves. Ours is a goodly heritage. Let us not destroy it by seeking to extend it. Let us be simply what we are, and we shall be always well off. Let us elaborate our works, and men will admire them and seek them: in our talent they recognize their ideal, that which captivates and enchains them.

As you receive the *Courrier des Dames* you must have noticed that the fashion-plates are much improved. There is, however, one capital defect; for the most part they are impracticable, and the reason is very evident: these styles are designed by men, who cannot be familiar with what is suitable for us. So there are always false knots, false buttons, placed where there is nothing to tie —nothing to button. There are some models of dresses in which it is impossible to move about or breathe. We can have no idea how the taste of woman has been corrupted by the sight of these doll-figures, nor how many young girls have laced so as to destroy all their freshness, in order to attain the shape of a fashion-plate.

I trust your daughters have not fallen into the sin of deforming God's creations; that they possess the grace and suppleness of their mother; that their movements are free and easy; in short, that their forms are properly developed, notwithstanding those women who compress the waist until they are as stiff as cuirassiers.

When one learns to draw, dear friend, a little instruction upon beauty is not amiss. There are so many erroneous ideas regarding beauty! Detain your daughters a moment before the Venus of the pagans, or the Eve of Christendom, so often represented by the great masters, and ask them if these forms are made to wear the costumes of our fashion-books. Weep, poets of the *Almanach des Muses!* Those wasp-waists you have sung are now only deformities.

In these master-pieces, which are such simply because they are the image of fair nature, the shoulders of woman are narrow and sloping; any costume, therefore, which tends to elevate or enlarge them, is absurd. The head is small; it should not then be increased in size and overloaded. With square shoulders and a large head, woman fails in distinction and elegance.

Your daughters will recognize these truths in looking over their collection of old engravings. They will agree with me that, if women were to design the modes, their costumes would regain the feminine character

which they are now losing every day; that we should be at ease in our apparel, without sustaining any loss. We are not alarmed at a change of fashion, while men are very pusillanimous. For, perhaps it has escaped your notice, that since 1830, men have fought for liberty; they have delivered many orations upon liberty; whence it arises that they have fought again for liberty, and that they begin anew to prate of liberty. But, after all, it is the women who have broken their chains. They educate themselves, and they dress as they please. They wear, without embarrassment, the most extraordinary ornaments of distant countries. Dress materials have no longer, as it were, any fashionable season. There is, indeed, a fashion, but it is the slave of each woman, who modifies it according to her caprice, while formerly, women were the slaves of fashion; such slaves, under Louis V., as to wear perukes with a fair suit of hair, and to shave it, *a la* Titus, under Napoleon. Now every woman arranges her hair to suit her face.

But men dare not discard their stove-pipe hats, nor their frightful black vestments, in which they are married and buried. To change one's costume is a great audacity; it exposes one to peril.

The barrier is overthrown; what metamorphoses await us in the future! I should like to come to life again in

two thousand years, and see what woman will be then; would not you?

<p style="text-align:right">M. E. C.</p>

P. S.—Drawing is an art which renders woman truly feminine. It increases her love of home, by teaching her to render it attractive. It imparts taste in ornamenting her house, and in designing the dresses and hats she orders, and which she may make herself, if she knows how to draw. Drawing and painting do not oblige a woman to show herself in public in order to call attention to her talent. It is, in a word, an art which lends modesty and wisdom, which subdues imagination to the control of reason.

EIGHTH LETTER.

LESSON.—METHOD OF TRACING FROM NATURE AND THE CAST.

EXPERIENCE has taught me, my dear Julia, that pupils who have traced much and drawn outlines from the cast, shade easily.

For this reason, in ordering models for my method, I have placed those from the cast in the second series.

The time has arrived, therefore, to execute the second and third series, before commencing to shade, so that

the pupil learns to trace while drawing the last models in outline.

When the pupil can correctly trace a front face from the cast, and make a good proof, it is evidence that she understands how to find the outline in the shadow.

As it is much more difficult to find the outline in the shadow, than to shade, it follows that undoubtedly the pupil has already overcome a great difficulty.

In making outlines from the cast, then, and in correcting them with the proof, the pupil has constanly before her eyes a shaded cast, either a head, foot, or hand; and by studying the outline conscientiously, she very naturally fixes the form of the shade in her mind.

The proofs from the cast, and from inanimate nature, should, therefore, be studied simultaneously with the second series of models, and afterward the outline models of the third series, which are entire figures, with outlines from the cast, corrected with the proof; then draw again from memory.

It is highly important to study the hand from the cast, since the position in nature is generally bad. Very few persons place their hands naturally with a correct and supple movement. The hand is easily benumbed, and becomes stiff.

For a franc, one may easily procure hands moulded after nature.

The outlines from the second series of casts give the pupil some idea of the perfection to be manifest in her proof, the method of taking the different faces and profiles of a head, foot, or hand; then the size to be adopted for tracing upon glass, when the pupil wishes to enlarge her model.

These models made by pupils of my method prove that the instruction therein given is the truth, and that every one who follows it exactly will arrive at the same results.

Pupils who wish to render themselves better acquainted with what I have suggested can procure simply the foot of *Clodion* (easier to transport) at the office of "L'Ane Savant," 69 Boulevard Saint Martin, with the shaded models, which cannot be obtained elsewhere.

The outline series may also be obtained there, together with any information regarding professors.

But how shall we learn to trace from nature and from the cast?

You take an ordinary wooden chair with barred back, such as are seen in the public gardens; then procure a board 5 centimètres in width and 1 mètre 30 centimètres in length; fasten it to the back of the chair, by passing it between the bars, so that it may be inclined forward, and make a back. (7).

When seated in the chair, the pupil's head will naturally be supported and steadied upon this board.

Let Mary be seated ; then bring the gauze before her with its base, letting it slide in its grooves until just on a level with her eye.

She will place her head perpendicularly so that she shall move neither to the right nor the left, and steady the base of the gauze with her feet so that it will be firm. Then she bandages one eye with a handkerchief.

She will have previously prepared several well-sharpened pieces of charcoal.

These steps taken, Eliza will place herself motionless before Mary, who will draw her head upon the gauze, as it appears to her, making only the outlines. The nearer Eliza is to Mary, the more closely will the drawing approach natural proportions. Another means of enlarging is to remove the delineator from the gauze. For further experience, study for yourself the different modes of enlarging. Nothing is easier: By receding from or approaching the object to be drawn, different proportions are obtained.

In commencing, have your pupils trace hands and feet from the cast in the largest possible porportions, so that they may become familiar with the form of the outline. This exercise will give them a better understanding of nature.

It is a general rule that in drawing an entire figure or a cast, the distance of the delineator from the model should be three times its height. Thus, if the model, seated or standing, is one mètre in height, the delineator should place himself three mètres distant.

Another important rule: the centre of the object drawn should be on a level with the pupil's eye. For example, in drawing a chair, she should be seated upon the floor, supporting her head against the wall or any solid body. The chair, so difficult to put in perspective, suddenly appears perpendicular upon the paper, as upon the floor.

To avoid sitting upon the floor, a model-table may be used, placing upon it the objects to be drawn. A model-table, which should be five feet in width, six in length, and a foot in height, is, however, an inconvenient and cumbersome piece of furniture. It is perhaps better to accustom ourselves to sit very low. That is a matter of choice. But the elevation of the seat is determined by this rule: the centre of the model should be on a level with the eye.

You will find more pleasure than you anticipate in taking this little course of perspective. From chairs, furniture, etc., you will proceed to trace all the corners of your room, the stair-case, vestibule, anything you please. But notice, if you are not seated very low, the

floor will rise like a mountain. It is just so with landscapes.

Your daughters will acquire facility in tracing correctly by practising upon inanimate nature. By inanimate nature, we mean all that has not life, that does not move about—furniture, houses, dead animals, casts moulded after nature, sculpture, etc. Before inanimate nature the outline will become more clear, more delicate, but not without application, not without patience.

To prevent your pupils being discouraged at the outset, select objects with the most simple lines. Do not forget an important point in this lesson: your pupils will alternately make drawings from the second series of outlines, and proofs from the cast. Then outline drawings from the cast, and from the third series—entire figures.

It is fatiguing to trace more than ten minutes consecutively: the vision is dazzled; the head, which must be held perfectly still, becomes wearied, and the arm unsupported is benumbed.

In directing our studies, we must take strength into account. When fatigued we lose all our faculties. I have not lost that of loving all three of you.

<div style="text-align: right">M. E. O.</div>

Note.—For further details, see sixteenth letter,

addressed to the professors of the schools upon the method of tracing from the cast.

NINTH LETTER.

LESSON.—METHOD OF SHADING—UTILITY OF THE GAUZE.

Now we come, my dear Julia, to shaded drawings from the great masters.

Sketches from the masters are executed with red crayon. Shaded engravings with black.

There are three series from Raphaël, Titian, Poussin, Van Dyck, Rubens, etc.

The first series is indispensable.

The second must not be given till the first is finished, and the third after the second.

The second and third series are appropriate New Year gifts, for the engravings are worthy of being framed and hung in your daughters' rooms.

However, if you have good engravings from the masters, the figures in which are at least from 25 centimètres to 30 centimètres in height, you can avoid this expense.

The size of figures is that adopted at the Academy of Fine Arts.

Still, I ought to mention that you will never find as fine ones for the same price.

When your pupils have finished these three series, they will have acquired a talent by which they can maintain themselves if necessity demands.

The series answer, also, for drawing in sepia as well as for water-colors, so that this expenditure once made, there is nothing more to pay for models or masters.

I have found it difficult, my dear Julia, to make choice of models of nude studies which are suited to young girls.

The task is accomplished. The public will recompense me for my pains, as I shall announce this good news in the fourth edition of my method, in which I have revised, corrected, and added many things that experience and the lectures of my professors have given me.

I had already made some improvements, you know, in the third edition. I will refer you to the sixteenth letter for advice upon shading and adopting the method best suited to the ability of each pupil.

When the outline is well secured with lead pencil upon the paper, the half-tint is added to the whole, by rubbing either with the finger or with cotton wadding. The charcoal is employed in the heavy portions, the lights taken out with a crumb of bread, and the outline

finally redrawn with a very fine charcoal over the crayon which disappears.

These operations, which succeed each other rapidly, give the pupil a thorough comprehension of masses of light and shadow, as well as of the half-tint.

One does not obtain pretty pictures in this way, but artistic designs, while by adopting the method indicated in the sixteenth letter, they are at the same time finished, and upon a grand scale.

But both methods are beneficial, and help to impress the results upon the memory.

The outline drawing, as well as the shaded one, should always be made from memory.

It is well, my dear Julia, to give your pupils different methods of operating; it sets their wits to work, as they say, to find a method of their own.

There are pupils who, to increase the black, add crayon sauce, which they use with the crayon itself, without touching it with the finger.

Others retouch the flesh with red crayon.

Others, to obtain greater vigor, use the charcoal again, and after having fixed it twice, fix it the third time.

In landscapes, it is well to finish the trees in the half-tint before fixing it the first touching up.

Wonderful landscapes in charcoal may be drawn in this manner.

When my pupils draw landscapes from nature, they begin by making their traced proof in the morning; they study the outline from that, draw it from memory, and replace the outline upon the half-tint. Then, from two to six o'clock, when the effect of the landscape is finest, they dispose the lights and shades, and complete studies worthy of the best masters.

Every day's experience advances their progress. They are following a course so safe and so true, that willingness and application suffice for their advancement.

Some of the pupils of the professors of my system have suggested the idea of making a third drawing without the proof, to satisfy the incredulity of persons who tell them they trace.

I will say here: A pupil should never trace if her teacher makes the proof for her; it would only retard her progress. The pupil's sole aim in tracing, therefore, is to make her own proof; that is to say, her instructor.

I promised to speak of the service M. Rouillet has rendered to art in introducing his gauze frames.

Invaluable as this invention is to my method, I assure you I am not partial.

The ancients traced from nature through a frame, as your daughters have done through the gauze.

This process was attended with great disadvantages. For every tracing it was necessary to put a preparation

METHOD OF SHADING. 69

upon the frame in order that the pencil might leave its mark. The transfer of the drawing to paper was very difficult. It often happened that the frame was broken. This has given success to the invention of M. Rouillet.

In my opinion, the stretched gauze possesses great advantages. It is always ready, does not break, gives the lines perfectly correct, and the transfer of the design is made in the simplest manner.

In this way:

When your tracing is finished, you fasten a sheet of paper perfectly straight upon your board, and over this paper you place the gauze perfectly straight also, taking care that it touches equally everywhere. For the rest, if your daughters fail in some, they will do others well.

Experience is necessary even in the smallest matters.

You are ready to say now: "But if one can thus trace nature, what need is there of learning to draw?"

One must be very skilful, my dear friend, not to disfigure these tracings. The process can only be truly useful when one thoroughly understands it.

The stretched gauze is like the photograph; it does not kill art; it only illumines it; and you will see what service it is to render us now that your daughters understand tracing.

Then you pass over the outline again upon your gauze, and the impression is left upon your paper.

You next take a sheet of transparent paper which you place over the drawing (transferred from the gauze to the paper), and, looking at your model, you make a proof.

To me the utility of good tracing lies in the proof. I use it as an instructor in drawing from nature, a severe exacting master, whom the pupil heeds, for it is to the pupil he speaks.

It demands and obtains the precise dimensions proposed; an excellent thing, for in composing, the figures must be of the size required by the dimensions of the picture.

Thus the same instructor, under whom you have copied the model, comes to your aid in drawing from nature.

When your daughters are sufficiently disciplined in this school, they will become instructors themselves, and will spoil no more proofs in making use of them. On the contrary, they will improve them before nature.

They will thus have learned the laws of perspective, with no other rule than the truth through which they look; for the gauze is truth.

The drawings repeated from memory being traced from nature, will fix objects in their mind just as they are.

And as they take great pleasure in drawing from

memory, as they wish, you say, to learn how to represent everything, I trust they will thank me for opening before them so rich a career. All the works of man— all the works of God are now theirs. As a reward for so much, I ask only a little place in their heart and yours.

<div style="text-align:right">M. E. C.</div>

TENTH LETTER.

OBSERVATIONS.—VARIETY IN LIGHTS AND SHADES. DIFFERENT ASPECTS OF NATURE.

Well, my dear Julia, does the shading progress to your daughters' satisfaction? "No," you say? I am expecting such a response.

They have seen what are called young ladies' drawings, and are eager to begin that pleasing work. Such a talent is, however, of no value. It may always be acquired by time and patience, but wins success in nothing; it is an imbecile triumph. The use of the crayons, the science of drawing, will give your pupils this accomplishment, and something better. Besides, I will teach them, by-and-by, a process of executing most elaborate drawings. But you must not think of that at present.

They should now apply themselves to a more serious subject, that of properly adjusting lights and shades, as in mezzotint. It is all-important.

For when they take up water-colors, and must use a brush to indicate light and shade, will the pleasing work of pretty drawings render them skilful in painting? Certainly not; the difficulty in water-colors is not to feel your way, but to strike unerringly.

Therefore it is impossible to succeed in this species of painting unless memory assists intelligence in the presence of nature. The chief science, the first talent requisite, is that of understanding what one does, of hitting exactly the light, the half-tint and the shade, as one hits exactly the form of outline.

To this end accustom your daughters to notice the effects of the light:

How figures are illumined;

Why shadows exist.

Without thus studying nature, they will always make poor copies from models.

Teach them what a projected shadow is: one object casts a shadow upon another; the rim of a hat upon the face, a ruffle upon the hand, a piece of furniture upon the floor, etc.: and we, ourselves have our projected shadow which follows us everywhere.

You remember the pretty German romance of Peter

Schlemild, who was so unhappy because he had sold his shadow to the devil. Well, an artist would be quite as much to be pitied if his were not at the point of his pencil. It is the shadow cast which gives life, air, position.

Its forms vary according as the light is higher or lower. In the open air, have you never observed how shadows contract or lengthen as the sun ascends or descends?

At night, by lamplight, shadows are very strong and very exact.

Another observation:

The light is always excessively sharp upon the hair, because it is glossy, and upon a round body. Well rendered, it gives form to the head.

Satin goods receive also a very sharp light.

It is broader upon silk, and still more so upon woollens, cotton, and linen.

In drawing stuffs, we have the shadow, the mezzotint, the light, and the reflection.

Generally upon polished surfaces, such as crystals, marbles, porcelains, metals, varnished woods, gildings, etc., the lights are very rare and sharp. It is important to know this, for the light indicates the material and the quality. Thus, in a drawing, a new piece of furniture differs from an old through the manner of disposing

the lights. Little by little all these observations will find lodgment in your daughters' minds, and be brought forward with the pencil at the proper time and place.

As soon as they understand how to look at objects, they will no longer see them without giving attention to the form of the lights and shadows.

They will see how monuments, buildings and thatched roofs become illumined.

Nothing will escape them, neither the great masses of shade and light upon the trees nor the shadows thrown from the clouds, which sometimes throw a whole village in the shade and again leave only the tall spire luminous.

Upon the seashore, the effect is magical, especially in the northern countries, where the sky is nebulous.

The effect of the light is also much more varied and striking in the north than in the south. The cloud is the friend of the colorist.

An entirely new life is dawning for you and your daughters. To your eyes, every work of nature begins to assume an interesting aspect. The artist witnesses each moment the most marvellous sights. When traveling, he experiences a thousand varied sensations. He goes from wonder to wonder; where others see and feel nothing, he beholds, compares, admires. He might pass over the same route twenty times without fatigue.

for to him the fascination is always new, every hour of the day, as often as the effect changes. And this effect extends even to the smallest things: there it is a cow on which the light falls, that enlivens an undulation of the plain; here a cottage, reflecting the sunlight, and assuming, through the tufts of foliage, proportions of admirable beauty.

To express the exalted happiness I have often experienced in these contemplations would be impossible. We seem to approach nearer God in more clearly comprehending His creation, and we bless Him for having bestowed this faculty of appreciation. In a word, we feel rich in all we see, and in view of the indifference, or rather the insensibility of those around us, we seem to possess the world alone, while some beneficent genius unveils to us wonders which are concealed from others.

How often, in the presence of nature's marvellous works, have I pitied the presumption of those men who attempt to give us an idea of paradise. What! far from inventing the beauties of this world, you die without having comprehended them, and you would invent the things of heaven! But the heaven of your imagination, oh men! will never equal God's earth, and no one wishes it to be so. As for myself, while patiently and gratefully enjoying the blessings of this world which I love, it is my prayer to be admitted, one day.

to the companionship of those whom God has reserved for us in his presence. But I should think myself unworthy of them if I presumed to form any idea of the happiness which awaits us on high, and which I invoke for you all. Thus may it be!

<div style="text-align: right">M. E. C.</div>

ELEVENTH LETTER.

OBSERVATIONS.—NUDE FIGURES.

You write, my dear Julia: "There is one thing that alarms me in seeing my daughters become artists. An amateur talent no longer satisfies them. After three months of study they speak of composing, and have attempted it already. This drawing from memory excites their imagination, and impassions them, even, to such a degree that they deny themselves the pleasures of the ball, because the preparations consume time, while their highest delight is to hoard up drawing after drawing in their portfolios."

What joy I experience in reading this passage in your last letter! I see that, far or near, all my pupils are the same.

Eliza, you tell me, prefers to compose jewels, vases, ornaments. We have done well, then, in teaching her

all varieties of drawing. Nothing is an obstacle to her; she follows her vocation. Her instinct develops itself; the taste for curiosities, that bric-a-brac which inspires fanaticism, will supply her with many little pleasures. It will cost her something, perhaps, but her savings will be well expended. The love of ancient things involves a host of good lessons.

Mary collects engravings. She wishes to be a painter. If I remember right, she has an eye for color. It is wonderful. Each of your daughters pursues a different path. Their work will possess a two-fold interest for their mother, and there will be no rivalry between them.

It is needful that I calm your apprehensions; your fear that your daughters will become real artists only by drawing nude figures from nature.

Have I not said, that woman should never, under any pretext, forget her womanhood; that to be a woman is her first condition in life? Woman possesses a nobility which she should preserve before all things else. Courage, will, devotion, perseverance, delicacy of sentiment, self-respect, or in other words, dignity—these are her titles. These virtues constitute woman, and give her as much control over herself as she naturally maintains over others.

I cannot, with this high estimate of our sex, desire

any thing which would depreciate or dishonor her. I wish, on the contrary, to reinstate the name of woman-artist.

I am well aware how it is regarded at the present day; it suggests a woman who assumes masculine manners and habits, an amphibious being who is neither a man, nor yet a woman.

I have never been able to see the necessity of that in acquiring talent. On the contrary, the prime requisite of originality is to be always perfectly one's self, and to represent that self in one's works. Why am I devoted to painting children? Because I love them supremely. To see them move about in my studio charms me; all their motions are beautiful. I shall never have time to execute all they inspire within me. It is because they are natural, and this naturalness is God's style, His work.

If a woman would be thoroughly herself, she cannot well represent a Hercules, nor a battle. She must confine herself to those subjects which are allied to her sphere; which possess, in some degree, her qualities, and to which she can assimilate. It seems to me her domain is large enough, and beautiful enough. As I have said elsewhere, with women, children, animals, fruits, flowers, etc., one may create master-pieces for a lifetime.

Man, then, who cannot be properly represented by woman, ought to be excluded from our studies for this reason, and for a much stronger one, which it is not necessary to explain.

Children and partially nude women; these are the extreme limit for us. Yet these half-nude figures are necessary only for ornamental sculpture, for clocks, vases, jewels, etc., and you will agree with me that for these, they are not at all inappropriate. The subject is always mythological, and they are not colored.

As to figures in costume, it is perfectly useless to paint them nude at first, for the purpose of dressing them afterward; worse than that, it is destructive. It is impossible for a nude person to take the " movement " of one in costume. The dress gives the action. It is quite true that the different costumes of different countries give different styles. The cast follows the costume. If the costume has style, so has the cast. Thus the women of Pont-l'Abbé, in the heart of Brittany, as they wash their linen, have the air of grand ladies compared with the washerwomen in the suburbs of Paris.

You see, my dear friend that there is no necessity for my pupils compromising their womanly dignity, in order to become great artists; that, on the contrary, they will attain an exalted position in art, only by retaining in its highest sense their womanhood.

We know very well how to exercise judgment in saying only what we ought to say. Why should we not possess the discrimination to represent only what we ought to represent?

It is precisely this reserve which will constitute the charm of our works, and which will make them successful also, for no door will be closed to them; there will not be a family where they will not be admired and wished for.

At a time like the present, when liberty to do wrong seems to obtain favor, let us adhere to the privilege of doing well; it is better than the other.

There may, perhaps, be some giddy young girls who will say, It is wearisome! The boys are free, but we are not.

That is true, the girls are like white satin dresses, which are not free to display themselves in the street. Of what do they complain? That they have the best of the bargain, and that the bride is too pretty.

<div style="text-align: right">M. E. C.</div>

TWELFTH LETTER.

LESSON.—FACILITIES FOR LEARNING TO DRAW FROM NATURE, AND TO DRESS A LAY FIGURE.

Since your daughters, my dear Julia, have already made upwards of two hundred drawings from memory, and have repeated them in a variety of proportions and at different intervals, since drawing from memory has become so familiar that they even attempt to represent what they have caught a glimpse of, we approach the goal—we are prepared to take up nature.

Among the models of your series choose a lady's hand. Let it be executed with lights and shades, and afterwards drawn from memory.

These two drawings very carefully done, you will place your hand in the same position as the model, with the same lights thrown upon it, and your daughters will draw it, taking notice of the differences which exist between your hand and the model they have just copied. Nothing more is necessary to seize and to render nature, for the skeleton is always the same. and that gives the movement. Then remain only the details of flesh more or less plump.

This first drawing from nature will astonish you at

least as much as the first drawing from the model and from memory.

From feet and hands, for we commence with those you will pass to figures which you will dress and adjust upon nature as upon the model. You will execute them in the same manner, but always after the drawing from memory.

You will proceed thus with all the good engravings which you can reproduce from nature, entirely or in part; animals, flowers, fruits, furniture, all are adapted to exercise the eye, the mind and the hand.

From these, you will return to your first models, and select those which your daughters have retained best —those which can be reproduced from nature. They will make this reproduction, and afterwards, execute them from memory. This reversed exercise will be one of real utility.

Now, as your pupils trace nature so well through the gauze, as the outline has become fine and clear, you can teach them to trace shadows. Inanimate nature is preferable as a beginning, for the work is very difficult. The first drawings will be, as they usually are, mere scrawls; but little by little they will become excellent. This study should alternate with that from nature—one aids the other. (8.)

It is now time either to borrow or purchase a lay figure

Your daughters will dress it in imitation of a costume taken from some ancient engraving. There is art and even pleasure in arranging the position and dress of a lay figure. You will find all the old goods of use, and that none of the cast-off articles from your toilette need be lost; ribbons, flowers, old waists, all these, with the aid of scissors and pins, may be made to assume any form you wish.

The lay figure thus dressed, you trace the stuffs with the shadow, in order to study the form of the folds. The model being motionless, the pupil can execute leisurely.

The pupil need draw only the outline of the face and hands of the lay figure. If, however, she can finish it from the engraving which has served as a model, I have not the least objection.

This exercise is excellent. It is important to give all attention to it, and continue it until worthy results are obtained.

While waiting for the lay figure, you might throw drapery over a chair and let it be traced. Art and skill in the fold are very essential things. As your daughters have already studied it in the ancient engravings, as they have already drawn drapery from memory, they will now, in the execution of these tracings from nature, make rapid progress, and, like all my pupils, reap the fruit of their exactness and perseverance.

If they esteem it great happiness to bring me their portfolios, I shall be no less happy to visit them. But above all, do not let them pass too quickly from one lesson to the other. I should readily notice it.

Upon each lesson I send you, there are entire months of work. So I do not use too much haste in writing you. I understand your impatience to see my letters arrive; to be familiar with the whole of my method. You fear I shall leave you in the lurch. Be assured, I could no more renounce this labor than the old friendship I cherish for you.

<div style="text-align: right">M. E. C.</div>

THIRTEENTH LETTER.

OBSERVATIONS.—MODELS—PORTRAITS.

I wish, my dear Julia, to notice one advantage which we women possess over other artists. They are dependent upon models who make a business of posing, and who go from studio to studio. Thus they have almost always the same natures before them, and at the expositions, one sees the same figures in the pictures of different painters. Those who do not live in Paris, experience another difficulty. They cannot procure models. You

will find some, although you live thirty leagues away from the Capital.

I reside in Paris, and I have never studied position from what is called a model. I find models everywhere; among the seamstresses, and other workwomen; they always prefer posing to working.

Among the little unfortunate beggars, whom I encounter; I can understand why a mother would not like to have her daughter pose as a model in an artist's studio, but she leaves her with confidence here with the mother of a family.

Finally we have our friends and their daughters, who certainly would not wish to pose before strangers.

Our models are, therefore, much more varied, much more *distingués* than those of painters; I should say more natural, for we take them from real life, with their own style and gestures, while the professional models have almost always an artificial air.

This leads me to speak of portraiture.

There is not a more delicate art. A person who moves about, who speaks, does not exhibit imperfections like a mute, motionless picture.

We always examine a portrait too closely. We notice it more in one day than the original in ten years.

A portrait initiates the beholder in details he had never before observed. For example, we often hear a

person say, when looking at a portrait: "It is a good likeness, but the nose is too short." Then turning to the original, he adds: "Why! I never observed you had so short a nose—but you have a very short nose; it is astonishing how short it is." And if it is a young girl who sees the portrait of her intended, and she happens not to like very short noses, there is a matrimonial failure.

Indeed, the majority of portraits render no other service than to hold up your imperfections to view. That is agreeable! You pay the painter, therefore, for thus betraying you!

Observe the greatest precision in the contour of the head, in the manner in which it is placed upon the shoulders, and in its relation to the rest of the body. This is the first rule for the painter, the most important. It is so true that in the darkness you recognize by his profile a person who enters your house. You distinguish him even by his back.

The gauze gives this precision.

Afterwards the line of the hair and the position of the features should be indicated without immediately attempting to express them.

In order that the portrait shall not bring into prominence the imperfections of the face, they should in the first place be well understood.

If the nose is too short and too far from the mouth, you lengthen it a little without touching the mouth, and the two defects are softened. If on the contrary, the nose is too long, you shorten it a little, always without touching the mouth, in order not to alter the division and contour of the face. It is highly necessary to avoid this, for we seldom fail to notice whether our acquaintances have long or round faces.

But you may enlarge the eye a little, and still preserve its form; contract the mouth somewhat through the expression given to it, or rather by that one of its expressions which you adopt.

Always seek the beautiful in painting faces, and whatever deformities they possess will become far less prominent, or will even disappear.

Study the character of a head; try to discover what strikes us at first sight.

There are persons who possess this faculty naturally, and they take likenesses before they know how to draw.

I call that a good likeness which pleases our friends, leaving no room for our enemies to say, "It flatters!" And this is no easy achievement. How many good portrait painters are there—that is, painters who combine real talent with the art of producing a good likeness? Very few.

Often a simple sketch is a better likeness than a portrait.

Do you know the color of all your friends' eyes?

Certainly not. If a painter whose profession it is to observe, has the misfortune to lose his wife, he can rarely paint her portrait from memory. It results from the fact that we notice our immediate acquaintances very slightly. Hence this question arises, Is it necessary that the portrait painter should show us more than we have been accustomed to observe?

Examine the portraits painted from photographs; not one in a hundred is endurable. Why is it so? I have seen the Boulevard Montmartre reproduced by the same process. I am thoroughly acquainted with it, for I was born there. Indeed, I should not have recognized it. And why is it? Because it is not regularity of feature which impresses and charms us, but the *tout ensemble*—the expression of the face; for every one has a physiognomy which strikes us at first sight, and which a machine can never render. In painting, and above all, in portraiture, it is the spirit which speaks to the spirit, not science to science. It is then the spiritual which must be understood and rendered in the person or object drawn. Now, this spiritual has a thousand different faces. There are as many expressions as sentiments. It is a great and wonderful work of God, the formation of so many different faces with a nose, a mouth and two eyes. For, who of us has not a hundred countenances? Will my portrait of this morning be that of this evening, or

to-morrow? Nothing repeats itself, each instant brings a new expression.

From the preceding, should I infer that, in order to paint a portrait, one must be either very wise or very ignorant?

I shall be accused of speaking paradoxically, but I will explain myself.

An ignorant person notices very little in a face; he sees the essential, that is, aside from the harmony of the features, that individuality which prevents us from mistaking one person for another.

He renders it naturally easily; with no attempt at coloring or style, he blunders into the truth. He makes a guard-house portrait, as they say, but it is a good likeness.

When one emerges from this ignorance, and begins to understand the face somewhat, he is in the condition of those persons who, having read medical books, imagine they have all the diseases therein described. He has a half science which enables him to see, but falsely, and he affects wisdom at the expense of the unfortunate ones who have confided their faces to his care. In fine he knows too much to be naïve through ignorance, and too little to attain simplicity through science, while superior talent may preserve naturalness in color and drawing. Not only are their portraits good likenesses, but they are works of art which posterity will preserve.

Certainly my paradox is true, as is also the friendship I bear you.

<div align="right">M. E. C.</div>

FOURTEENTH LETTER.

OBSERVATIONS.—FEMALE ARTISTS.—POINT OF VIEW, PERSPECTIVE.

You write me, my dear Julia, that handsome M. L— said to you yesterday that you were wrong in bestowing so much talent upon your daughters; that men do not usually like lady artists, etc. There is some truth in that; but you might have replied that ladies do not usually like pretty boys. Why is it that a talent, a gift, injures those who possess it? For this reason: A man, if handsome, is usually effeminate, and loses his manhood; a woman, very often, when she is an artist, becomes a man on a small scale, and ceases to be wholly a woman. Each is unnatural. Men do not know how to render their beauty acceptable, nor women their science. They are too much enamored of themselves for any one to attempt competition with them.

Your daughters are too well trained to part with their good manners.

As talent enlarges, modesty will increase; for no rep-

resentation of nature can equal nature herself; the love of order will assume firmer control, for the precision I have constantly enjoined, naturally precludes all disorder. In everything, disorder is a loss of time which no true artist can desire. You should see the studios of the painters, whose fame has reached your ears! They are models of neatness and taste, all their surroundings are symmetrically arranged, and they like this system, this elegance in their toilettes, their wives and their children.

Why, then, should a lady artist lose the qualities of her sex, when she sees them regarded by an artist as among the necessities of his art?

This is, therefore, a prejudice which will become extinct with those who proscribe the blue-stocking, when women shall retain their womanhood in authorship as in music.

It is not their talent which is disliked, it is the absence of those qualities which belong specially to them ; and they are criticised so much the more keenly when distinguished by talents of a superior order.

The defects of the obscure woman are ignored ; those of the celebrated woman come into notice with herself. Talent is like rank; it places one under obligation.

But to return to our art. You ask the meaning of those lines placed upon several of your models, and inclining

toward the same point. (9.) That point is the point of view. Nothing is more useful for the correct observation of the rules of perspective; that is, the disposition of the various objects and giving them their proper proportions. As seen in your models, sometimes the point of view is in the picture, sometimes out of the picture; again it is accidental, when an object, a chair for instance, is placed outside the general perspective of the picture.

When your daughters have traced with the gauze a home scene, or a house in the country, they will only need seek the point of view, and they will find their tracing gives it exactly.

The perspective is thus easily found without a master. But I repeat that it is necessary to sit very low, upon a footstool, in order to make the point of view acceptable. There are certain modes of taking it which are not correct, and the picture is made to please, not to instruct. Besides, the spectator always having the picture hung on a level with his eye, it is very natural that the artist should take this point of view.

When your daughters wish to introduce several persons in the home scene which they have traced, in order to gain a better idea of the perspective of the figures, they will have a model pose successively at all the different distances behind the guaze, and the tracings they make from it will give them the exact proportions to be ob-

served. Thus, immediately, the perspective of the background and of the figures will be in complete harmony.

This harmony is a prime necessity, especially in landscapes, where the figures not being in proportion the effect of distance is lost.

By drawing a line from the point of view to the feet of the figure in the foreground, and another line from the same point to the head of the same figure, one may determine the proportions of all the figures between these two lines.

And for the rest, experience teaches me every day that when a pupil has become familiar with tracing through the gauze she learns to discern the perspective and put everything in its place, as it were by instinct. The point of view, with all its lines, delineates itself before them. Like M. Jourdain, who for sixty years talked prose without knowing it, your daughters will one day be astonished at hearing the learned precepts given in teaching perspective, that science which they are acquiring without being aware of it, and which they will put in practice as the nightingale sings without learning the notes.

If, in the future they are not satisfied with doing we'l under my instructions, if they must have further explanations and are desirous to become learned, they are free to do so.

There are persons who, after having eaten and digested well for thirty years, awaken some morning with the desire to know the structure of the stomach and how it operates. Their digestion will be no better for it.

It is an excellent trait in woman not to attempt the thorough comprehension of all things, and if it were not an instinct with her it would be great wisdom.

The how and the why sometimes disenchant the most beautiful objects, distort the noblest sentiments, and obscure the simplest truths.

May your daughters never need to ask why and to what extent they are loved. Many things must remain mysteries to us, aside from my prattle about the arts, which I close here with these words: Work, persevere, and do not belie the proverb, that "a woman must have her way."—*Ce que femme veut Dieu le veut.*

<div style="text-align:right">M. E. C.</div>

FIFTEENTH LETTER.

COMPOSITION.

What say you, my dear Julia, you are not yet weary of my prattle upon art? How noble and beautiful is friendship! Love would say: Let us pass on to something else.

You ask for two words more upon composition.

I notice with pleasure, good and tender mother, that you prefer my advice to that of M. the Count C—, and that you wish to render your daughters independent by giving them true talent.

You will thus defend them against reverses. Beauty and talent are two things which socialists cannot share with us.

Mary, you say, reads history and attempts composition upon subjects which attract her. This course is not a safe one; it has sometimes made shipwreck of splendid genius.

How many artists of our own day, in attempting subjects suited to governmental purchase, or in executing those assigned them, have lost their reputation! They have attempted something beyond their ability.

Is a work begun at the ending? What would you think of an architect who should travel in search of models for doors and casements of an extraordinary form, without having the least idea of the building he wishes to construct, or of the ground upon which it is to be located? Well, that is just what Mary, your painter, is doing.

As to Eliza, your sculptor, I must compliment her upon her collections of shells, butterflies, birds, and insects; with her, I admire her lizards, serpents, and

even her toads. What treasures for her compositions! Eliza is in the right. I should advise her now to make a collection of flowers also, studying them with the magnifying glass, even to their minutest details, dissecting them and making drawings of each separate piece.

This will prove wealth of another kind, which like the ant, she stores up in summer for the winter's use. A provident architect, she collects materials wherewith to construct her edifices; for time-pieces, vases, jewels, are little edifices of grace and beauty. An intelligent architect, she draws inspiration from nature, that unequalled instructor. By-and-by she will search mythology and history for names suited to her compositions if inclined to do so, always remembering however, that a woman is not young because she is called Hébé, but because she has a youthful form. The title does not make the work. The work itself creates its own title. How many artists are like goats, which, when fastened by a cord to a stake, begin at once even at the risk of strangling, to browze upon whatever is remote and difficult to obtain! It is wiser to begin with that within our reach, with the most simple, the easiest. Eliza does so, and she will succeed. This germ, simplicity, creates style, and style comes like everything else in nature, unconsciously. One little grain in the mind, and it is all there.

This little grain your daughters possess; drawing from memory has inspired them. They wish to create, one in sculpture, the other in painting.

Since you desire it, I will mention some of my principles in composition. Proceed in order.

Eliza wishes to make a chalice, for instance. She seeks at first an agreeable outline without occupying herself with details.

Shall the chalice be larger at the top or at the base?

How shall it be? She makes a variety of experiments. The smallest section of a flower may give her some idea.

Her first form chosen, she reflects upon the elegance she shall bestow upon each part. What shall the chalice be? A beautiful shell, a bell of flowers contest the ground. And now comes the base. The branches of trees, the feet of animals, animals themselves, children, etc., all immediately suggest themselves as supports for the chalice. She borrows nothing from what has been already made; all is the emanation of her own memory, and what is not suggested to day will come to-morrow; this is inevitable, with patience and will.

Mary should proceed in the same way; she should seek inspiration through her eyes and not from her mind study nature and not books.

Mary who wishes to make a picture, will begin by

seeking for the picture. Now, the picture is the background. The figures are a group which you introduce.

The sculptor is not placed under this necessity; his statue finished, he places it where he wishes. If he make a bowl, all he needs is a handful of earth, while, with the pencil of the delineator, half the bowl must advance, and the other half recede; that is, he must at the same time, make a projection and a depression upon the paper. Projections and depressions; that is the substance of drawing. It is a continual combination, the difficulties of which are great enough without creating new ones.

Mary will first attempt her picture without figures. Let us suppose she chooses the corner of a room, well exposed, or, in other words, reflecting fine masses of light and shade. She brings forward her lay figure, suitably dressed, and places it in a very simple attitude; for example, that of a person reading. In order that the subject may be striking, the strongest light should fall upon the figure and upon the book. The person is placed so as to make a happy composition, that is, a well balanced one. If not naturally so, it may be balanced by any suitable object, one which is appropriate and has not the appearance of having fallen from the sky, expressly to maintain a counterpoise.

Mary has a collection of old engravings; she may

consult those which relate to the subject she has chosen, or better still, she may make from them a living picture; that is, she may represent them in nature. This is a charming recreation which I advise you to repeat from several engravings. How many things you will thus learn! The engraving is black, but the living picture is necessarily colored. The pupil then begins to learn the value of colors as well as their effect.

She will see that there are tones which recede and others which advance, some tones and some fabrics which receive the light much more freely than others. She becomes a colorist before she is aware of it.

This is, then, excellent instruction for composition; in a good picture, there is a reason for everything, nothing is introduced by chance. The most unobserved object, that which seems most insignificant to the spectator, is sometimes so necessary that, if it were taken away, the picture would in great measure lose its effect, nor even would the composition be well balanced; for often a book, a handkerchief, a basket, thrown down as by chance, balances a person or even an entire composition.

The engraving reproduced in nature, has other advantages, which I leave you to discover for yourself as you follow your pupil.

For the rest, it is somewhat in this way that the celebrated Vaucanson taught himself; he took a clock to

pieces to study its mechanism, and put it together again by looking at another which served him as a model.

By thus drawing inspiration from the works of the masters, Mary will at length succeed in composing entirely alone, what I should call a living picture; the Reading, for instance, which I have mentioned above.

Let us see how she will execute it.

She will place herself before this picture, at a distance triple the height of her figure, and seating herself upon a footstool, she will endeavor to make her composition come within the limits of her gauze, by closing one eye. The isolation she thus gives her picture, will make its defects more palpable, and enable her to improve them. When she is satisfied with the adjustment, she will trace it with the charcoal upon the gauze, in all its details, in order that everything may be well proportioned. From the gauze, she will transfer it to a paper stretched upon pasteboard, putting the whole perfectly square. The point of view obtained, starting from this point she will go over all the lines with a rule and crayon; she will previously have traced the perpendiculars and horizontals, as they are regularly formed with a square sheet of paper folded in four. The architecture thus designed, she will now pass the crayon over all the rest of the drawing.

When she has secured her composition, constructed it thoroughly with the crayon, she will go over the whole

with the mezzotint tone in charcoal, and then she will take up the strongest shades. She will be familiar with the value of the shading, she will know that the darkest are always light, if she takes care to put a piece of black velvet over the foreground.

Nothing now remains but to relieve the lights, which is done with a piece of bread, beginning with the most luminous point of the picture, for it is simply a picture, which she has just made. The whole should attract at first sight. Mary is free to caress it afterwards, to improve it, always, however, without altering the masses.

In the course of time she will risk the addition of one or two figures, but without effort, above all avoiding pretensions in painting, and seeking the form, that which pleases the eye.

A number of figures should be grouped so as to form a harmonious and well-balanced whole.

You must have observed that whatever the shape of compositions they have a unity, that they present a whole to the eye.

The figures form a mass, and gaps are avoided. Gaps are the spaces between the figures which it is very difficult to fill with the background. This is why the artist takes pains with them in composing.

Light, also, possesses form which makes a mass. Sometimes it is a garland, sometimes it rolls like thun-

der from one corner of the picture to another, and it often serves even to balance the composition. The manner of lighting up a figure, may render the movement true or false, appropriate or unsightly.

You must now understand, what I have said above; that it is easier to find a subject for a well adjusted scene from nature, than to arrange the scene from a subject found in a book. As a proof of this, we never find a notice behind the pictures of the old masters, and we discover in them two subjects oftener than one. Deeds, actions, are to be represented, not narrations. I remember a notice thus worded: "The artist has chosen the moment when the saint offers his soul, full of love, to God." It were thoughtful thus to apprise the public, since neither soul, love, nor God were visible.

Composing a picture is not creating a strange, fantastical thing. It is, on the contrary, a representation of something which exists, or has existed. The one which most nearly approaches truth, is the most successful. An unnatural creation is a monstrosity.

A strong-minded person said to me one day, "If Jesus Christ had truly been God, he would have taken another form than that of man, to come upon earth." "Since he has taken this form," I responded, "it is because he knows your nature better than you know it yourself. He knew that a being not classed in your

catalogue would be denominated a monster." Every-thing represented out of nature has the same effect.

I once heard a painter say: "I am about painting a very original picture. I have an entirely new subject." What an error! It is the talent which must be original, not the object represented. An original talent is one which resembles no other talent. It may execute the most commonplace compositions, but it will always be original. It is the manner of first beholding and afterwards executing, which is peculiar to you. Can anything be more trite than a cavalier with his horse? Yet, executed by a great artist, this would be a very original subject.

Must originality then be sought? Certainly not; as I have already said, all should be trusted to the guidance of one's own genius. Recall my comparison, a little aspiring, perhaps, of the river and the canal. Every artist errs when he pursues a path different from the one nature has marked out; so he rarely grows under hot-house culture. Unfortunately the talent, the success of cotemporaries occupy too much his attention, and cause him too much anxiety.

The great geniuses of this world are like trees and flowers, which, far from destroying each other, are of mutual benefit. Does the rose injure the carnation, or the oak the linden? If the rose were to borrow the

foliage of the carnation, original as it is, what would be gained? Yet how many artists borrow certain qualities from their rivals, thereby destroying the characteristics of their own talent! Be yourself, and seek improvement without ceasing to be yourself, and you will do well.

Shall I make you laugh a little? Suppose a woman with an aquiline nose should affect the manners of one with a turned-up nose, she would be perfectly ridiculous. With the latter one can say many things which are impossible with an aquiline nose.

And how many noses there are which never ought to waltz? For (I do not know that you are like myself) when my friends waltz, I perceive the true form of their noses. These noses in turning and returning complaisantly in all directions present most grotesque appearances. How I laughed one evening with Ambroisine at a waltz of noses! If Cham could have transferred my impressions, what an amusing album he would have made!

With this I embrace you as closely as a nose *retroussé* can embrace an aquiline.

<div style="text-align:right">M. E. O.</div>

SIXTEENTH LETTER.

LESSONS UPON THE UTILITY OF THE TRACED PROOF—STUDY OF THE GAUZE—THE CAST—MODE OF SHADING WITH THE CRAYON.

I ANNOUNCE, my dear Julia, the fourth edition of "Drawing Without a Master." Since, with the permission of the mayor, you are very desirous of teaching drawing to the children of your parish, this new edition is the best. For this reason; in opening a course of lessons in the month of November, 1850, I wished to experiment upon my method with a large number of pupils; as much to introduce all possible improvements as to give to the public positive results.

The results exceeded all my expectations. Out of seventy pupils only two were unable to make the drawing from memory the first day, and made that attainment only after two or three months of study.

I have the certainty, then, that out of thirty-five pupils, thirty-four possess eye memory—a faculty, which, until the present time, has been held of little value in giving instruction, yet from which so great an advantage may be drawn.

All the artists who have examined the drawings I have obtained day after day from my little girls, are

convinced that with my method months are equivalent to years with the ancient system.

THE TRACED PROOF.

These are the improvements which practice has suggested, and which I cannot too strongly recommend to you, as well as to the heads of all institutions and schools.

The transparent paper is preferable to the gauze for making the proof, which must serve as a professor. To secure all the fine points of the model, the proof should be made with a lead pencil. With the gauze, the pupils may deceive, either by making the impression upon the paper, or marking through the errors committed.

The transparent paper is free from this inconvenience.

When, like yourself, my dear Julia, a mother is the instructor of her own daughters, her surveillance suffices, but with a large number of pupils the master's eye may be deceived. It so happened with me, and I lost no time in replacing the gauze by the transparent paper. As you will see, its office is much more simple.

You will understand that my present remarks refer to the traced proof made from engravings.

The pupil will place the proof over the white paper so that they shall be even. She will then fasten them at the top upon her board, also evenly, with two paper

tacks. (10.) The proof and the white paper thus secured she will indicate the starting point of the drawing by puncturing the transparent paper so that it shall leave an impression upon the white paper. She will then only need to lift the proof up from the bottom to copy her model, starting from the puncture, and she will lower it whenever she wishes to correct it. Sometimes it is more convenient to fasten the proof at the side, in order to turn it from left to right.

When several pupils are thus installed in a studio, the spectacle is a very curious one. While copying, you would say they were working at a trade, but when the copy is finished and they begin to draw from memory, a ray of intelligence illumines all their young faces. Already the artist stands revealed. It is necessary to be very exacting as to the purity of the proof, and it depends upon the pupil to make for herself a good one. Do not forget that upon the transparent paper the tracing is finer and consequently more exact. To convince my pupils of the importance which attaches to this, I have in my studio a collection of proofs which have secured very excellent results.

STUDY OF THE GAUZE.

None but pupils who are accustomed to trace from nature can correctly trace outlines from a shaded

engraving. For this reason I wish my pupils to trace frequently from nature, from the beginning to the end of their sessions.

Commencing, as I have mentioned elsewhere, with motionless objects, such as furniture, vases, casts, fruit, flowers, etc., I compel them to study nature, and this leads them to understand the art of the masters they copy, either in foreshortenings or any other difficulty. They no longer copy with the hand alone but with the intellect. Every outline they make has its significance.

The study of the gauze is full of interest. Pupils are very far from possessing the same proclivity for this exercise, which is generally very difficult; but the results are none the less wonderful. Notice the traced proofs which I have had lithographed at the close of my first series of models. Some of them are the work of children of eleven years of age; part of them after three, others after six months' study. I ask, my dear friend, how one can err with such professors! It is nature herself; and Raphael has reproduced her no better.

And if the pupil traces the portrait, she attains still greater skill, for tracing from the cast is not only much easier, but conveys more instruction.

You will see this by casting your eyes upon the traced professors of my second series of models. The pupil exhausts all the profiles; all the aspects of a head, hand

and foot. She thus renders an exact account of their forms and their connection with the neck or limbs. I have been accused of teaching only the processes—the mechanical part of art. What an error! I cast aside old rubrics, and I frankly bring the pupil to an encounter with nature herself.

Incontestably, heads, feet and hands, include the greatest difficulties of drawing. If, after three or four months of study, you give your pupils an entire figure to copy, the extremities are always the most deficient parts. It is well, therefore, sometimes to condemn them to fifteen days of feet and hands. They will make faces as though they were put on bread and water for fifteen days, but success will soon console them. When a pupil can draw a hand she is already very skilful; she has acquired much experience in foreshortenings.

OF THE CAST.

In schools, the cast offers one great advantage; a single one serves for several pupils at the same time. They place themselves around it at the height and distance indicated in my eighth letter, seated as before the drawing models with their transparent paper, upon which is traced the proof, and which they can put down upon their drawing to correct it.

Although the first proofs may be lithographs, it is well for the pupil to make them herself previously through the gauze. She will thereby only become better acquainted with her professor. (11.)

A single gauze will suffice for several pupils, provided you are systematic in your work. When seated around the cast, each at her point of view, they take their turn in tracing through the gauze. Meanwhile some make pages of shading or capital letters, others reproduce from memory what they have drawn the previous day.

Thus no time is lost, each awaits her turn patiently and in perfect silence, for the study of drawing imposes silence. The proofs finished, all the pupils take up drawing from the cast, correcting their errors with the proof; then the cast and drawing are taken away, and it is left for memory to reproduce what the hand has already traced, but which the eye no longer sees.

Good proofs from the best pupils will serve very well for others. In my ninth letter I mentioned the process of transferring the tracing from the gauze to the white paper. It is there retained by a well-known process. The pupil, upon his transparent paper, makes a new tracing which becomes his professor before the same cast and in the same position.

Thus the head of the class has all her professors in her portfolio. Every day increases her collection. It is a

species of mutual instruction which I have practiced in my studio with great success.

When the pupil uses the gauze as a professor, she traces then, in beginning her drawing, a cross which is naturally transferred to the white paper. The two crosses carefully placed one upon the other, how simple and how exact the corrections will be! Could they be more so?

If the pupil wishes to enlarge her proof, she retraces not upon the gauze, but upon a pane of glass, enclosed in a frame of the same dimensions, in order that it may be placed upon the same stand, and take the place of the gauze. The glass should be glazed over with a coating of gum water, which is allowed to dry. Thus prepared, it receives perfectly the drawing of the lithographic pencil, which imparts more sharpness than the crayon.

The glass may be filled with tracings. It is well even to have several glasses covered with good tracings, in order to be able to devote an entire session to enlargements. Experience increases interest. I have explained the manner of enlarging in my second edition, last letter.

The proofs thus enlarged, should like the others, be fastened upon paper and carefully preserved by the heads of the school. They answer as professors for all their pupils. I call those good proofs which are perfect. The most inexperienced eye can tell immediately a good proof from a poor one. Neither do the pupils deceive

themselves; they are generally severe in the choice of those adopted as their proof-professors.

This leads me to add that you must distrust the gauze, which is not so reliable an authority, I might almost say person, as one would suppose.

If it is not well placed before the model, there is no precision in the outlines; on the contrary, the drawing is awkward and resembles nothing. Observe carefully and with your own eyes, that is compare the results with the models and ask yourself the reason for the differences. If a hand or an arm is suspended too high or too low, if the pupil is seated too near or too far from the object, if the gauze is not placed directly in front of the model, it effects errors in lines, foreshortenings and positions which make one's hair stand on end.

Place a pupil before a piece of furniture; she will see that when the lines of the frame of the gauze do not coincide with those of the furniture, the perpendiculars incline to the right or left, the horizontals rise or descend in such a manner as to give an entirely different point of view.

Whoever is familiar with the gauze, not only will avoid these faults, but will conquer finally the greatest difficulties in art. With it, one can make true frescoes, that is, figures which sustain themselves in air, and not those which must apparently fall upon the head if they should suddenly be endowed with life.

SHADING WITH THE CHARCOAL.

One word now, dear friend, upon the improvements which experience has taught me in the method of shading with charcoal; nothing is more simple; the charcoal is rubbed upon the paper with the finger precisely like pastel. With the finger alone one is able to model. Give at first to all the strongest parts their proper value; lighten with a white stump or with your finger the portions which are too dense, thus making them a half tint, and extend this half tint everywhere, so that you may afterwards take out the lights with a crumb of bread; that is the whole secret.

When pupils shade from the cast or from nature, it is highly important not to permit them to shade anything whatever, without joining thereto the background, no matter what it may be. It should be copied very precisely. Indeed, nothing in nature exists without a background. It is giving the pupil a false education to allow drawing upon a background of white paper, when behind her model she sees an entirely different one, dark or light with varied tints. The harmony and the differences existing between the background and the object drawn, give the latter a body, atmosphere, space, and prevent it from looking as though riveted upon the paper.

It will cost the pupil no more, immediately to adopt the habit of combining the background and the object drawn. On the contrary, they furnish mutual aid. But how shall we avoid losing the outline in shading simultaneously, the background and the object?

In order to model boldly with no fear of losing the outline, it is always preserved upon the gauze, in order that, if it should be effaced, it may be restored by placing the gauze upon the drawing. You know whatever is drawn upon the gauze may easily be transferred to the paper beneath it. They should avoid undertaking at the same time, both sides of the object they are drawing, in order not to lose all its outline, and to preserve some marking points which may aid to adjust the gauze and to reëstablish the outline.

Thus the pupils will acquire incredible boldness in modeling. The fear of losing the exact outline, as we have seen, will no longer render them timid in modeling. They will become like the great masters to whom drawing from memory has given at once correctness of eye, and firmness of hand. It will not do, however, to require too much of beginners. The essential thing is, not to allow them to become accustomed to a false outline which corrupts the eye; this is not to be feared with my method, so long as they have nature before them. It is only in drawing from memory, they may be deceived.

Happily they are always conscious of what they do, and always pass severe judgment upon their drawings from memory. They know where it is at fault, and this proves that the glance of the eye is already correct before science is acquired.

Another Method of Shading with Charcoal.

When the pupil undertakes to copy an entire engraving, here is a process by which she may execute this copy in a short time.

After putting the charcoal lightly over the whole sheet, holding it almost flat upon the paper so that it may not make wrinkles, the pupil must rub it with her finger or with a bit of woolen, until an equal tone is attained.

This tone should be about the value of a half tint.

Thus spread over the whole surface of the portion to be shaded, the pupil draws the outline of his model upon this half tint. But to prevent the hand from removing it in drawing, the pupil previously draws the outline upon the gauze, then transfers it upon the half tint, just as upon white paper.

The outline and half tint thus put upon paper, the pupil takes a crumb of hard bread and takes out the lights very carefully, not omitting a single one.

The drawing thus executed has already a very interesting aspect, for in a moment the pupil discovers an important thing; that the light is rare and the half tint is the dominant one in the art of making a picture.

She then takes the fixative mentioned at the close of this letter.

She spreads it on the *back* of the picture with a brush, so that the paper is entirely covered with it on the wrong side of the drawing, of course.

To prevent the drawing from touching anything during this operation, the pupil should have it held by the two corners, lowering always the sheet on the side where the fixative has flowed. But little should be put on at a time.

It is well to hang the drawing afterwards on a curtain, in order that it may dry without touching the wall.

There you have the outline, the light, and the half tint fixed irrevocably when the paper is dry. It is then the pupil retouches the shades with the crayon, always rubbing with the finger as vigorously as she pleases.

All depends upon the charcoal crayon and the paper in order that the fixative may adhere and the charcoal become very black.

The pupil should try her paper and her charcoal. Save the soft ones for the background, the hard ones for outlining, and the blackest for shading.

Experience alone can guide her. She must make and remake unweariedly.

For I can confidently assert that with this process crayon drawings will finally reach such perfection as to be as clear as photographs.

The shaded series from the great masters, executed thus by pupils, sell for parlor ornaments. Many persons prefer them to painted copies of the great masters.

Pupils will thus make portraits as delicate in finish and complete in resemblance as photographs. But they combine expression and life as only the human hand and the eye can give it.

DRAWING FROM MEMORY.

When your pupils draw from memory, show them the model from time to time, in order to render them very conscientious in their execution, and then, when they draw alone, they will be in the right path.

Teach them the first principles of beauty; that between the two eyes, for instance, there is a space equal to the size of the eye; eyes too widely separated give an unintelligent air; the eyes of cattle are placed thus; in monkeys, on the contrary, they are too near; that the lower part of the ear should be on a level with the lower part of the nose, but placed higher it may still be beau-

tiful; that there should be the same distance between the hair and the eyes, as between the eyes and the lower part of the nose, between the lower part of the nose and the chin; that the mouth should be near the nose.

Teach them to observe, in order to place the mouth properly beneath the nose, how the two little lines are framed which descend from the nose to the upper lip.

For the rest, when they draw after the cast, they should trace separately the eyes, mouth, and the lower part of the nose, together with the mouth, also the ears.

The pupil may place herself as near as she wishes for this species of exercise, in order to make her drawing larger and to become acquainted with all the details and all the profiles of an eye; a mouth with the portion under the nose; an ear, just as she knows all the profiles of a head and its position upon the neck; that a little head and a straight neck are always in harmony with the beautiful; this they will see in the models of the third outline series, in drawing antique statues, of which I have made a suitable selection.

There they will learn the proportions of beauty by being made to count how many times the height of the head is contained in the length of the body.

There are books where all these things are mentioned again and again; but is it not better for the pupils them-

selves to take a compass and compose the proportions from the antique statues and from the masters? For example, in taking the measure of the forearm, and comparing it with the other part of the arm, they will be convinced it is the same. They will see afterwards where the elbow ought to be in relation to the body, and compare likewise the leg and its height.

From all these comparisons they will find many measures are the same.

This is a most interesting task to perform upon the magnificent models of our method, which are all executed from the masters and the antiques.

The pupil in seeking to render herself familiar with the proportions of the beautiful, engraves them, as it were, in her mind.

Thus with a proof made from an antique, she will be able to draw lines from all the points. For example, from the small of the arm to the point of the shoulder, then she will put a dot at each measure.

She will then trace her figure with nothing but the lines and points, and if she has taken the measures well from those portions of the body which bend, she will see and understand the movement.

Thus has often been made a caricature of two men who fight with swords, which almost all children have reproduced.

She will, in the same way, take all these points and lines from the face for the outlines of the countenance. This little task, with the compass, should be done in the evening. It is a great diversion.

When the pupils discover that the masters have deviated from the rule of beauty, they will understand that nature herself often deviates.

It is well to know the principles of the beautiful taken from the antique, but it will not do to abuse them. For this leads to a conventional style of painting, in a word, to the school of David, of which I have already spoken to your daughters, in the third part of "Drawing without a Master," sixth letter, in an appreciation of the talent of Ingres, Horace Vernet, and Eugène Delacroix, published in the journal "L'Ane Savant."

I have still so much to write upon art! Eugène Delacroix was right when he said to me, "Books will be made with your book if you do not undertake it yourself." Therefore I continue it in that journal, in order to converse with my pupils, who are scattered in the four quarters of the globe.

More than two thousand have already responded to the appeal of this journal. You see that encouragements are not wanting.

You will like, my dear Julia, to follow the progress of the young girls, of the School of the Sisters.

The more numerous they are, the more you will appreciate the value of my lessons. You have, as is quite natural, attributed the happy results you have secured to your daughters' superior talent. Your ideas will change, however, and you will soon be convinced, by your new experience, that everybody can learn to draw as one learns to speak his language. It is as simple; and very nearly approaches the genius which creates new forms, elegant and chaste architectural ornaments, designs for fabrics, costumes, furniture, vases, etc., and the productions of the art will finally bear the impress of our manners and habits.

<div align="right">M. E. C.</div>

P. S.—METHOD OF SECURING OR FIXING THE CHARCOAL.

The charcoal is secured upon the paper by means of a very simple preparation. Put half an ounce of white shellac in three-fourths of a pint of alcohol, cork it well, and let it dissolve for two days. With a little sponge, spread this preparation upon the back of the drawing, letting another person hold the sheet horizontally.

SEVENTEENTH LETTER.

EXPRESSION.

You must know, my dear Julia, that the gauze is no more a modern invention than the glass. Leonardo da Vinci, in one of his letters, speaks of it under the name of *stracci*. Perugino, Raphael, and many others, among the old masters, made use of it. No one can doubt it who traces draperies. The thousand little folds so perfectly adjusted, with those who have used the gauze, are entirely overlooked by those who are ignorant of it.

The contractions of the fold can be learned only with the traced proof. None, save artists who have traced, have solved those problems of perspective, the obscurity of which seems only increased by demonstration, but which eye-memory enlightens almost unconsciously.

Nevertheless, art could never have fallen into the decadence we deplore, had not the means of acquiring readily the talent of execution been neglected and lost. For, at eighteen, Raphael was already a great artist, and he died at only thirty-two, leaving so many wonderful masterpieces

Never could I believe that men are more stupid at one epoch than at another. Their intellect changes the

object of pursuit, that is all. Sometimes they excel in art, sometimes in science, sometimes in manufactures. It is likely that at the time of the revival of art, all means of arriving at truth in drawing had been exhausted. Correctness of form did not satisfy; the artist sought expression to give it life This was the zenith of art. But soon expression was exaggerated, and it usurped the place of truth. Then came the decline. The history of Greek art presents the same phenomenon. When truth ceased to be valued it was despised; tracing was forgotten. Poetry, no doubt, still lingered, but science, and the ability to execute, were gone.

Not forever, thank God! They must return, and have returned to France, in the wake of daguerreotyping. Yes, a *savant* suddenly appears, and terrifies artists by saying to them, "You know nothing!" The public is astounded at the news that human ingenuity has surpassed itself by means of an invention, easily reproducing objects by the action of light upon a metallic surface. But gradually terror and enthusiasm calmed down on both sides, and without ceasing to admire the pictures produced by the daguerreotype, they exclaimed, "It is nature without life." And in truth an inanimate machine cannot impart what it does not possess: soul, expression, poetry. Man, however grossly and imperfectly he may create, will always be superior to mechanism,

he enters into his creation and animates it with the sacred fire God has kindled within him. This is true not only in drawing and painting, but also in sculpture. A machine has been invented for sculpturing marble, which exactly copies the model. It has been dispensed with, because its productions were only mechanical. The same is true even of the works which civilized nations now require only at the loom. Look at the cashmeres of India, so superior to those of France, although the tissue may be often far less perfect. It has the unexpected caprices of a living being.

Everywhere is seen the artist who invents, who seeks to please, and whose success is doubly gratifying, because he has conquered a difficulty and created something beautiful. The machine, whose work is so exact, so regular, so perfect mechanically, is far from causing the same emotion; it is the monotonous parrot which forever repeats the same words without understanding them.

It is thus with the daguerreotype, invariable always —yesterday, to-day, and to-morrow. Everywhere the same truth of design and perspective, the same correctness—nothing is forgotten; it is perfection. And yet you remain like ice before such masterpieces! Wherefore? Because the genius of man is wanting, and there is a voice which obstinately demands it; because exterior forms do not satisfy us, and we can be moved only by

that internal something which emanates from the canvass or the marble and reaches our intellect and our heart Who shall impart this something to the canvass or the marble, if not the artist?

But how shall one be a machine and a human being at the same time; that is, how shall one succeed, like the daguerreotype, in attaining truth naturally, at the same time preserving his freedom and force to give expression and poetry to his work?

I have discovered the great secret, my dear Julia, or rather I have rediscovered it, by reviving the art of tracing and converting it into an instructor. I do not boast of it, for nothing can be more simple. The idea is, besides, the offspring of the daguerreotype, and if it had not occurred to me it would have occurred to another.

The pupil begins by making herself a machine in executing her copy. There is her proof from which she cannot deviate, and perforce she arrives at truth. When found, it is reproduced from her memory, and, quickly freed from the preoccupations of mechanical execution, she can express her emotions and transfer her idea to her work.

Is it not wonderful, dear friend, how humanity revolves always in the same circle? Inventions, progress, revolutions all return at certain epochs to our earth, like those stars which reappear in the firmament after having

disappeared for ages. Science and art arise, advance, decline, and are forgotten in the wake of some great catastrophe, then spring up anew, only to improve, decline, and be forgotten again.

As the generations of man are numbered, so humanity counts its civilizations. At the dawn of each, when the night of barbarism is dissipated, art timidly revives, availing itself of the simplest means for attaining its object.

Egyptian and Grecian art astonish us always by the purity of their lines and the correctness of their movements, and Gothic art by its admirable simplicity, —qualities which are obtained only by a skilful use of tracing. At the birth of every school you find a style, that is to say, a truth.

When I mentioned the necessity of never allowing the pupil to shade any design whatever, without at the same time copying the background which is behind it, it was because I do not wish her to be one moment exempted from seeking the truth. It is highly important she should at once be familiarised with all the conditions of a picture. Thus, when she has copied a foot from a cast, or from nature, one would think it an imitation from the picture of some master; it almost seems to walk.

And it seems to walk because it has a footing. There is space between it and the background.

This is owing to the fact that the relations of tone have been well studied.

To find the harmony and the differences of vigor and light between the object you draw and what is behind this object, is the whole science.

Thus a studio cannot be too highly ornamented. Modern artists who aspire to become colorists, surround themselves with works of art, beautiful fabrics, rare pieces of furniture. None but the studios of pupils are bare, decorated with an eternal green or chocolate background. Thus, what is beheld in the first portraits which emanate from their hands? The green or chocolate background which for so many years they have had before their eyes.

Is that the way to teach them the value of colors, a thing so necessary?

In my studio, which is ornamented, the lay figure is always dressed in beautiful costumes, and the pupils are required to render in black the value of each color. Thus engravings could be made from their studies, so well are the white, green, red, and black understood.

That is undoubtedly much more difficult than to glue a figure upon a chocolate background; it is also more instructive. Better still, it is truly the science of coloring and drawing, which are inseparable one from another.

But I must stop, not because I have exhausted this science, but in order that what remains to be said may be understood; the mind must be prepared by the practice of my lessons.

I have nothing more to say at present, except to recommend perseverance in the work you have undertaken.

<div style="text-align: right">M. E. C.</div>

LETTER FROM M. ROUILLET.

METHOD OF ENLARGING.

My dear Julia, you wished to know M. Rouillet's method for enlarging drawings. I can explain it no better than he. Here is the letter he was so kind as to address to me:

MADAME:—

You express a desire to know my process of enlarging a drawing. I hasten to give it to you in a few words.

To enlarge a drawing, it is necessary to trace it upon a glass or upon gummed gauze, with lithographic ink Then take a small lamp, with flat wick, which can be raised or lowered at will. Cut the wick slantingly so as to make it very pointed. When it is lighted lower it until it forms only a small luminous point.

This operation I am describing can take place only in a dark room.

The lamp is placed before the drawing traced upon the glass or upon the gummed gauze, so that the luminous point shall be in the centre of the image; then the design is reflected upon the canvass or paper, which has previously been fastened upon the wall or upon an easel. As the lamp is placed nearer or further from the gauze, the reflection is increased more or less.

If you wish to obtain large dimensions, the tracing must be divided into four, six, or eight parts. The canvass or paper must be divided in the same manner, and the reproduction is made in portions, always placing the light in the centre of each. Thus the portion of the drawing contained in each little square of tracing is transferred to the larger corresponding square upon the canvass or paper.

It is scarcely necessary to add that whether the entire drawing is produced at once or in portions, it is necessary to delineate with firm hand the drawing which is projected by the light upon the canvass or paper.

I trust, Madame, you will be present at some lectures which I intend giving at M. Aubert's; it will afford me sincere pleasure to make you acquainted with the improvements which I have made in my method.

<p style="text-align:center">Receive, etc.,</p>
<p style="text-align:right">A. ROUILLET.</p>

NOMENCLATURE OF ARTICLES

INDISPENSABLE TO MADAME CAVÉ'S METHOD.

FIRST LESSONS.

The Cavé Method, entitled, "*Drawing without a Master.*"

First Series, Outline Models; heads, hands, feet, etc.,
A board.
Six paper tacks, carpet tacks or wafers.
Transparent paper.
White paper.
Charcoal.
Lead pencils.
Old gloves.

SECOND AND THIRD LESSONS.

Second and third series. Models from the Masters for learning to draw from the cast and entire figures.
A gauze with stand.
A wooden cross.

FOURTH LESSONS.

First series shaded. Models from the Masters for learning to shade with the charcoal and crayon.

FIFTH LESSONS.

The Cavé Method, entitled " *Coloring without a master.*"
Second shaded series; for learning to shade finely (from the Masters) with charcoal, to wash with sepia and to understand light and shade.

SIXTH LESSONS.

Third shaded series from the Masters, for learning style and composition.

These last two series answer also for studying coloring.

Outline Industrial Series. Models of houses, vases, chariots, etc., for elementary schools and children from six to nine years of age.

NOTES.

(1) In order to execute properly all herein mentioned, everything should be done according to the directions given.

(2) If the pupil has no gauze, take transparent paper, and follow the directions contained in the 16th letter, relative to the traced proof. This is the mode most generally adopted.

(3) To efface the charcoal take an old glove. Many pupils execute their drawings three times, first, corrected by the proof, secondly from memory, and the third time copied without the proof. It often happens that the three drawings coincide perfectly with the proof.

(4) Exercises in capital letters have been recommended to give the hand facility in sketching.

(5) There are pupils who execute the smallest drawings in charcoal, with admirable delicacy; this aids their progress in shading with the charcoal.

(6) Generally parents find it very easy to let their children spend five hours a day at the piano while they are willing to allow only one hour to drawing. This is because music pupils are obliged to play their pieces themselves, while they make their drawings with the aid of their teacher.

(7) A flat wooden cross will be firmer at the back if adjusted from top to bottom.

(8) It is well to mark upon the floor with chalk, in an exact manner, the position for the delineator, the model and the gauze.

(9) See the last two models of the third outline series.

(10) Carpet tacks or wafers will answer as well.

(11) It is well to procure the foot of Clodion which is traced and enlarged in the second series, in order to render one familiar with the perfection necessary in proofs taken from the cast.

www.ingramcontent.com/pod-product-compliance
Lightning Source LLC
Chambersburg PA
CBHW020917180526
45163CB00007B/2777